Praise fo

WHO RUNS THE

"Just as women's rights are human rights, women's progress is human progress. Achieving a world where women everywhere can fulfill their potential is the great unfinished work of today and the very work we must do to make progress. Lois Quam first worked with me over thirty years ago, and she demonstrates in her life and leadership—and now in her book *Who Runs the World?*—the resilience and creativity needed for this work. Lois shows how we can build the future we envision for us all by supporting women and girls around the world."

—Hillary Rodham Clinton
67th U.S. Secretary of State

"This is an inspiring book by an inspiring woman. Lois Quam is a leader, thinker, and mother who has put into words key insights about our world and how to change it. *Who Runs the World?* is a powerful call to new kinds of action and new ways of thinking."

—David Miliband
President and CEO, International Rescue Committee; 74th U.K. Secretary of State for Foreign Affairs

"Women's leadership in climate solutions is required everywhere. *Who Runs the World? Unlocking the Talent and Inven-*

tiveness of Women Everywhere rightly highlights the vital role women have to play. I see this at the global COP forums and in the local village. For anyone who cares about addressing climate change, investing in women is the catalytic move that can make all the difference."

—Sherry Rehman
Member of the Senate of Pakistan; Former Minister for Climate Change and Ambassador to the U.S. for Pakistan

"It is clearer every year that we cannot afford to pursue responses to one challenge at the expense of another. We need holistic, global solutions to climate change that also benefit sustainable development. So, if you want to make a difference on climate, add *Who Runs The World?* by Lois Quam to your reading list. Quam, a longtime partner with us on setting the climate agenda in Norway, shares why and how empowering women is at the heart of the sustained effort we need for climate resilience."

—Frederic Hauge
Founder and Leader, Bellona Foundation

"Lois and I worked to end preventable maternal deaths through the Saving Mothers, Giving Life initiative. I am delighted she has shared this important work and her vision in Who Runs the World. In it, Lois makes the powerful— and obvious but neglected—point that unlocking women's talent is key to addressing many of the challenges of the

twenty-first century. She's right and we can all do our part to make this happen."

—Christy Turlington Burns
Founder and President, Every Mother Counts

"Imagine a future where women and girls everywhere have the same opportunity to run the world. Lois Quam imagines and more. These stories of leadership decisions, experiences and lessons, provide a front seat view of her transformational allyship, and a key to unlocking the power of women everywhere."

—Mary-Ann Etiebet, MD, MBA
Merck for Mothers

"Lois writes *Who Runs the World?* as we mark a halfway point for the Sustainable Development Goals, set for 2030. Yet we already know we will not achieve many of these goals, unless we enable women to realize their full potential. At the core of this pursuit is the right for women to decide if and when they want to have children, afforded through rights-based family planning."

—Samukeliso Dube, MD, MPH, MBA
Executive Director, Family Planning 2030

Lois Quam

WHO RUNS
—the—
WORLD?

Unlocking the **Talent & Inventiveness**
of **Women Everywhere**

Forbes | Books

Copyright © 2024 by Pathfinder International.

All rights reserved. No part of this book may be used or reproduced in any manner whatsoever without prior written consent of the author, except as provided by the United States of America copyright law.

Published by Forbes Books, Charleston, South Carolina.
An imprint of Advantage Media Group.

Forbes Books is a registered trademark, and the Forbes Books colophon is a trademark of Forbes Media, LLC.

Printed in the United States of America.

10 9 8 7 6 5 4 3 2 1

ISBN: 979-8-88750-162-8 (Paperback)
ISBN: 979-8-88750-080-5 (Hardcover)
ISBN: 979-8-88750-081-2 (eBook)

Library of Congress Control Number: 2023916266

Cover painting by Edison Mugalu.
Book design by Analisa Smith.

This custom publication is intended to provide accurate information and the opinions of the author in regard to the subject matter covered. It is sold with the understanding that the publisher, Forbes Books, is not engaged in rendering legal, financial, or professional services of any kind. If legal advice or other expert assistance is required, the reader is advised to seek the services of a competent professional.

Since 1917, Forbes has remained steadfast in its mission to serve as the defining voice of entrepreneurial capitalism. Forbes Books, launched in 2016 through a partnership with Advantage Media, furthers that aim by helping business and thought leaders bring their stories, passion, and knowledge to the forefront in custom books. Opinions expressed by Forbes Books authors are their own. To be considered for publication, please visit **books.Forbes.com.**

This book is dedicated to hardworking, brilliant women everywhere. Our future is in our hands.

To: Gina —

With thanks!

— Lis

We believe it's time to unlock the talent and inventiveness of all the world's women.

Pathfinder, one of the world's premier organizations empowering women, girls, their families, and communities, works today in Africa, the Middle East, and South Asia.

With nearly seventy years of experience across one hundred countries, Pathfinders know that supporting the reproductive health and well-being of women and girls is essential for their ability to live the lives they choose and to address the challenges before us all today.

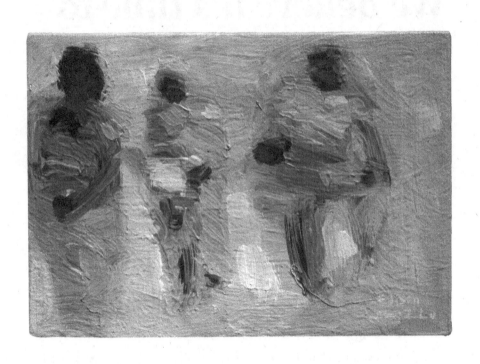

The Painting on the Cover, and the Painter Edison Mugalu

Edison Mugalu is a distinguished Ugandan painter. His work is imaginative, combining the light and energy of nature and people.

Edison grew up in a village in central Uganda's Kaynunga region using the colors from nature. Without access to commercially made paints, he made his own, combining yellow, green, and red flowers with ink to create the melody of colors in his paintings. Like many artists, he had a day job, devoting evenings and weekends to develop his talent as a painter. The Ngoma Artists Studio in Bukoto, a section of Kampala, provided him a welcoming community where he grew as an artist with mentors and teachers nearby.

I met Edison on a trip to Uganda when I was working at the U.S. State Department on Saving Mothers, Giving Life, a project to stop women from dying in labor and delivery. One evening in Kampala, a visionary USAID global health leader invited my colleagues and me to meet a group of remarkable Ugandan painters. Their work captured women's energy and world-changing potential in a universal way. I was struck by the way that art allows us to imagine new possibilities and feel connected with others.

The painting on the cover of *Who Runs the World?* offers the yellow of the sun that gives energy to everyone wherever we live on earth. It is the common energy we all share.

The painting also shows women emerging into that energy. For me, the impressionist nature of the painting suggests the opportunity for all women from all places, from all walks of life to emerge into the sunlight where we can each bring our full talents, energy, and abilities to bear forth the invention of a new world.

On days when my energy lags, I look at this painting for renewal. I hope that it may offer this sense of renewal to you too. The optimism represented in Edison's work is the kind of energy we need today to overcome the challenges we face across the world.

You can see more of Edison Mugalu's work at www.umojartgallery.org and Edison Mugalu/Facebook.

Contents

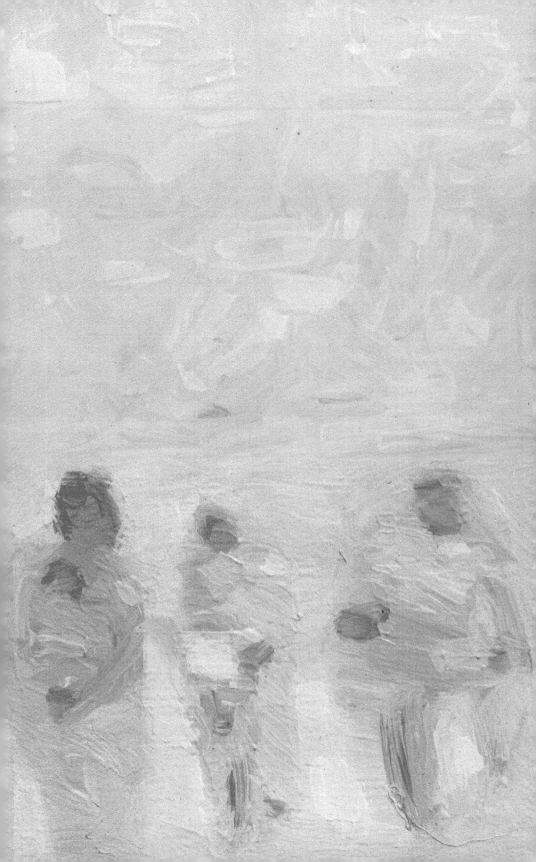

Preface

What makes the crises of the past 15 years so disorientating is that it no longer seems plausible to point to a single cause and, by implication, a single fix.[1]

Adam Tooze

Many of us feel the pressure of the challenges we face—both personal and global.

When we ask, in light of those challenges, "What can I do?" the answer we sometimes arrive at is, "There is nothing I can do that matters enough!"

I think that's because we need not a single fix but a "many fix." A fix capable of overcoming our sense of overwhelm.

As I see it, the "many fix" is right before our eyes.

1 Adam Tooze, "Welcome to the World of the Polycrisis," *Financial Times*, October 28, 2022, https://www.ft.com/content/498398e7-11b1-494b-9cd3-6d669dc3de33.

Today, most of the world's talent remains at home wrestling with the daily struggles of life. We need to unlock the skills, energy, and inventiveness of all the world's talent. We need everyone to have a chance to reach their full potential in life—for their own sakes and for all our sakes.

Unlocking the talent, skills, and energy of the world's women is the big move that can catalyze global progress in the twenty-first century. It is the "many fix."

Necessity is the mother of invention, so the saying goes. As a modern-day revision, I would say, we need more mothers to be able to be inventors.

The time is ripe for this unlocking move—everywhere and at scale. My time working as Pathfinder's chief executive officer has shown me that the highest impact decision that any of us can make is to support women and girls. We have the knowledge and the tools for women and girls to flourish; it's time we use them.

So, who runs the world? If you sang along to the Beyoncé tune in your head and answered, "Girls!" well, you're not wrong, but you're not right, either. Women and girls across the world have proven time and again that we are not to be underestimated. We are leaders, we are mothers, we are teachers, we are healthcare professionals, artists, scientists, wives—breadwinners and bread makers. Women comprise over half of the world's population, and yet every day around the globe, women die needlessly as a result of pregnancy. Perhaps when you think about this, you think first about women outside the United States who do not have timely access to safe, well-equipped hospitals. Surely, these women are at great risk. You'll hear many stories throughout this book from women and leaders in these countries—in fact, you'll read that these communities also have some of the greatest capacity to empower positive change—and it might surprise you to know that

the United States holds the highest rate of maternal mortality from avoidable causes among high-income countries.[2]

From rural areas to the wealthiest cities in the world, women everywhere are being left behind. Women so often do not have the resources to make informed decisions about their own healthcare, and even more importantly, women are so often not given the agency or the right to make those decisions. Instead, a woman's own body and life are heavily regulated—by legislators and community leaders alike. So many women are left to navigate a landscape—a world in which they contribute to half of the global good—wherein they have no real say about when, how, and if they have children.

When half of the world is disenfranchised in this way, who really runs the world? When women's and girls' health is regulated based on politics rather than on providing them rights and opportunities, what kind of world do we live in?

Today Pathfinder works across Africa, the Middle East, and South Asia so that women and girls—and their families and communities—can reach their full potential in life and contribute to their societies. The leaders and members of our teams—we call them Pathfinders—are from these communities. We are part of a global movement with sister organizations working in the United States and elsewhere. Across this movement, we learn from and support each other.

We see every day what it takes to unlock the energy, talent, and inventiveness of all the world's people. We often ask, if we can see this, why is it still so difficult to make it happen everywhere? Why is half of the world's talent left out?

2 Munira Z. Gunja and Laurie C. Zephyrin, "Health and healthcare for women of reproductive age," The Commonwealth Fund, April 5, 2022, https://www.commonwealthfund.org/publications/issue-briefs/2022/apr/health-and-health-care-women-reproductive-age.

I suspect that the answer has to do with all the ways those of us with access to power and resources grow comfortable with our own circumstances and busy with our own lives. When that happens, we fail to see how our well-being is shared by, and tied up with, others. We are interconnected. That is what I mean by the global good: We rise and fall together. We are interdependent. We can't do well unless others also do well.

The challenges in our world driven by changes in our climate, technology, global movements, and markets connect us all to each other. To invest in our own well-being is to invest in the well-being of others—including those we don't know in person or by name.

In this book, I share the stories of courageous women and men working in some of the hardest places and at the hardest times to benefit some of the most talented people in the world. We need women and girls in places far from where we live to thrive and prosper so that they can solve their own challenges and help us solve the world's challenges.

To truly impact change on a global scale requires each of us to answer the questions: What do we ask of ourselves? What is it about time that we do?

In my life, I've chosen to work on improving access to health-care. Yet at times, I've failed to see well enough the injustices around me. I have struggled to avoid looking away. But, over and again, I've been compelled to recognize how I benefit from powerful systems that—even in the very ways they are organized—perpetuate cycles of disempowerment.

I've asked, "What more can I do?" Answering that question led me to Pathfinder to invest in women and girls.

Asking "What more can I do?" shows how our personal choices are connected to some very impersonal systems. Changing those

systems turns out to be tied to some very personal choices. We know that when women can make choices about their lives, those systems can change for the better.

In these pages, I reflect on what more can be done to change the circumstances of women and girls—most of the world's people—so all of us have the opportunity, and the necessary support that must accompany any genuine opportunity, to choose the trajectory of our lives.

It's about time that we do this. For our own sake. For the sake of others. For the global good.

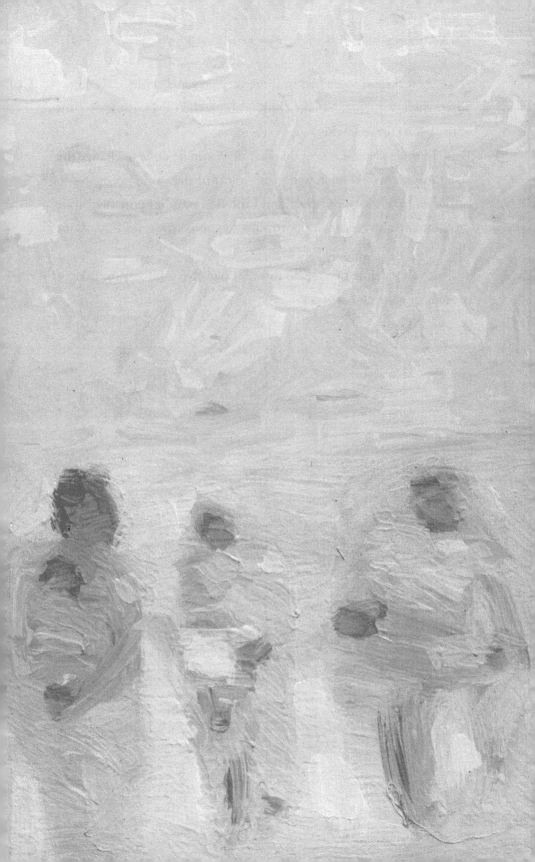

Introduction

I 'm in a well-lit, sparkling clean Minneapolis hospital room with walls painted beautifully light blue and white. The sheets on my bed are clean and fresh. Sunlight streams through my window on an upper hospital floor, and I enjoy looking out at the green treetops. At once, I'm exhausted, relieved, happy—and quite sore.

It is approaching two o'clock on a sunny July day, and this is one of the most significant days of my life. I can feel that. It is like my whole body is smiling. I have just delivered two beautiful boys. I waited thirty-eight weeks for this moment, the last seven spent in bed resting or, better said, lying in bed and trying to rest.

I delivered my boys in the hospital's operating room on a narrow steel table with an anesthesiologist, an obstetrician, a family physician, and several nurses by my side. An entire medical school class attended so that they could watch twins being delivered with the second twin delivered in the breech position. My obstetrician and I had agreed that I would try to push my second baby out but that I could have a Cesarean section in an instant if there were any difficulties whatso- ever. When my obstetrician came into the operating room, she shook my hand, looked me in the eyes, and told me that I was doing this

perfectly. Her respect for me, her empathy and compassion, moved me then and moves me now.

My first baby, Steve, was born smoothly and quickly, and it felt so strange to have just had a baby and still have more work to do. They brought Steve over to me, ever so briefly, but then I had to get back to work delivering my second baby, Will. The medical team plunged their hands into my still pregnant belly and tried to turn around my second baby so that he could be born head first. The result: no luck and a lot of pain. My obstetrician asked if I wanted to follow our plan to try and deliver my baby without resorting to a Cesarean section. I said yes, and she coached me to push gently. She flipped out Will's legs, and then I pushed out his torso and, at last, his head. My goodness! I felt this was truly one of the great achievements of my life, and I was so happy.

When I returned to my hospital room, the nurses brought these two beautiful babies to lie on each side of me. Holding my sons at my sides, I felt their warmth and noticed that they were quite pink and quite large—weighing in at seven pounds and seven pounds, fifteen ounces. With these two healthy, robust babies in my arms, the months of waiting for this moment and the weeks consigned to bed rest melted away.

I felt so, so tired. When I called my mother and father in Iowa to tell them the good news, I fell asleep mid-sentence. The nurses took the babies back to the nursery.

I vividly remember what happened next.

The nurses come in to press on my uterus so that contractions can begin. On their first press, a whoosh of blood goes everywhere. I see from the nurses' faces that they are surprised. I'm hemorrhaging.

Two things occur almost simultaneously: The nurses swing into action. I don't.

I don't feel anything. I'm detached, outside myself, there and not there, and still so very tired. I am almost watching myself and this scene unfold from above.

I feel one of the nurses give me an injection and hear another one announce that they are going to insert a catheter so that I won't have to get up from the bed.

The bleeding stops quickly enough so that no transfusion is needed. Before I doze, I understand that I lost a lot of blood, but at the same time, I feel that I am surrounded by all the care and support I need.

I sleep, and later, from my stationary position on the bed, begin caring for the babies. I am fine.

When my first son, Ben, twenty-three months old, comes for a visit, I am so happy to see him. He bounds into the room and says, "Mommy, there's a baby. There's another one baby." He is sure he is breaking the news to me.

From that moment, my future with these three beautiful boys unfolds.

Now, reflecting back on that deep-in-my-bones feeling of vulnerability alongside the certainty that no matter what happened to me, I would be well cared for, I can say that something about me changed for good in that hospital room—changed what I wanted to do with my life.

Ever since then, when I listen to or read the news about turbulent world events—extreme weather, war, or conflict—I think of those women in that very moment who are giving birth, whose time has come for their labor. Instead of finding themselves in a quiet, clean-smelling hospital room with caregivers on whom they feel they can rely, these women give birth in a subway bomb shelter because of war, in a field fleeing a flood, or in a clinic without electricity or running

water, in the dark of night without a skilled person at their side. That's what I think about when I read about the war in Ukraine, the floods in Pakistan, and the violence in West Africa.

I think about those women who live in a place where the help I could rely on simply isn't available.

Years later, when my twin sons, Steve and Will, entered college, and Barack Obama was the president and Hillary Rodham Clinton was the secretary of state, I joined the U.S. State Department as the executive director of the Global Health Initiative reporting to Secretary Clinton. On a trip to Zambia for the State Department, I had the chance to meet one of these women—a mother who delivered her first twin at a rural clinic and then rode three hours on the back of a motorcycle to deliver her second twin in a hospital setting. She took this trip for the same reason that I delivered my twins in the operating room. Her second twin was breech, and she needed to have a C-section. She traversed miles of dirt roads, hills, ruts, and bridges on the back of that motorcycle with a fully dilated cervix and her second baby pushing inside her. Such courage, such necessity. And happily, a healthy child as a result.

Another reason I did so well that day in the hospital was that I had access to good reproductive healthcare before my pregnancy. I'd had access to that care since the time I was in college. Prior to college, I had firsthand experience of what it meant not to have easy access to reproductive healthcare. I grew up in a rural area where the nearest birth control clinic was 90 miles away and access to a safe abortion was 150 miles away. Even going to a local drugstore to purchase condoms was risky, because everyone shopping or working at the store knew everyone else in town. Many of my high school classmates had a child too soon. They were nearly still children themselves. Some were unable to realize their full potential, because caring for children at

such a young age cut short opportunities that might otherwise have come their way.

Because of my access to reproductive healthcare when I went to college, I can say that my three boys were the products of two planned pregnancies—planned after I finished university and had started work. I gave birth to Ben when I was twenty-eight years old and to Steve and Will a month after I turned thirty. I had excellent postpartum reproductive care, so that my decision not to have more children—I feared having triplets next—turned out to be exactly what happened.

For the mother I met on that early trip to Africa, things were not as easy. To have access to needed care, she had to travel a long distance. In her immediate community, access to reproductive healthcare was uneven; sometimes local supplies ran out, and a full range of contraceptives was not available. She was fortunate that her community had put in place a system to provide transportation for maternity care. That's how she ended up on the back of a motorcycle, the driver tasked with taking her to a hospital where she could get the C-section she needed so that she and her second son could survive.

Doing What Matters

If you're like me, you've asked yourself questions like: How do I make my life matter? How do I forge my own path using the unique skills and experience I have to make a difference for others? These are questions that I've asked myself since I was a young person. This is the question that I asked again that day in the hospital, and in that moment the answer became clear. I decided to seek a path to help other women like me, like that woman in Zambia.

From early on, I felt certain that my most important work in life would be raising my three boys. But I also knew that I wanted to reach out beyond my own experiences and outside my own family.

Ever since that day in the hospital, I wanted to walk down paths where I could help other women who did not have as good access to the resources and support that were readily available to me. But the feeling that I could make a difference hadn't just come on the scene. I had that growing up on the Great Plains in southwestern Minnesota. To be sure, I was fortunate. My talent and inventiveness had been unlocked by my Norwegian American family, my Lutheran Church, and all the ways that the public schools and the broader community in Marshall, Minnesota, invested in its young people. My upbringing also created a sense that I was expected to give of myself to others. To whom much is given, much is required. There was no single conversation or pivotal event that taught me this. It was something more natural, such as the water and air around me. I learned, as I watched my grandparents, parents, and teachers, that life wasn't about having a comfortable private existence but rather about doing good in the world.

In my home state of Minnesota, my colleagues and I worked to pass legislation that gave health insurance coverage to hundreds of thousands of previously uninsured Minnesotans culminating in the passage of MinnesotaCare, a state-funded health insurance program.[3] I had this role as chair of the Minnesota Health Care Access Commission, a role that began with my oldest son Ben's birth—just five days before my appointment by the governor of Minnesota—and concluded as I was enormously pregnant with Will and Steve. After the commission enacted the legislation, Isabel Wilkerson of the *New*

3 Steven H. Miles et al, "Healthcare Reform in Minnesota," *The New England Journal of Medicine*, October 8, 1992, DOI: 10.1056/NEJM199210083271511.

York Times interviewed me about the Commission's work.[4] I was on my own caring for two babies and a two-year-old, and what was most memorable for me about the call was less about its content or the thrill of my first interview with the *New York Times*. It was more the fact that Ben swallowed a coin during the interview, necessitating a rapid end to that interview and the need to resume the interview later. Fortunately, Ben was fine.

The interview brought unexpected opportunities. Minnesota's leadership in healthcare reform led me to be invited to serve on President Bill Clinton's National Healthcare Task Force, charged with developing a plan to cover all Americans with quality health insurance. For six months, I went back and forth between being teary-eyed as I left my sons in Minnesota and energized by the work as I arrived in Washington, DC.

Later, when I held a leadership role in business, my colleagues and I worked on expanding healthcare access to low-income Americans served by the Medical Assistance program and for older Americans through the national Medicare program and the American Association of Retired Persons (AARP), the largest American civil society organization. The team of 27,000 colleagues I worked with to provide services in every American county and across England was dedicated and innovative.

I loved working in the corporate sector. The business of developing creative solutions to the challenges faced by individuals and society as a whole motivated me. The pressure of doing that work both sustainably and profitably inspired me to find more effective and efficient ways to work.

4 Isabel Wilkerson, "In Minnesota pressure builds for a health care insurance plan," *New York Times*, February 2, 1992.

After over two decades working in healthcare, my concerns about global health led me to focus on solutions to counter the worst effects of climate change. In particular, I focused on pension funds and other large investment vehicles that have the potential to shape the future by moving capital into renewable energy, clean technology, and energy efficiency. I saw this possibility most profoundly while working with the Norwegian Bellona Foundation on a vision for the large Norwegian investment funds to create stronger returns by more thoroughly managing climate risks. In their books calling for global action on climate change, Tom Friedman and John Doerr referenced my recognition of the economic investment opportunities that can fuel the transition to a more just, green economy.[5]

One day, as my colleagues Marius Hansen and Terje Mikalsen and I drove away from a business meeting in Porsgrunn, a town in southern Norway, we emerged from a tunnel cutting through the mountains just as my phone rang. It was Hillary Rodham Clinton, the secretary of state, asking if I would join her again in Washington now that my twins were about to go to college. When my colleagues talked with me about staying in Washington working with the Clinton administration at the time that she was First Lady, I had said no, because I wanted to raise my three sons in Minnesota. This time, those sons were headed to college, and I was free to join her. Hillary Rodham Clinton is a leader who knows how to unlock the talent and inventiveness of the world's women.

Saying yes during that phone call opened up a path for me to serve my country by working at the U.S. State Department to advance

5 See Thomas Friedman, *Hot, Flat and Crowded* (New York, NY: Farrar, Straus and Giroux, 2008) and John Doerr, *Speed and Scale: An Action Plan for Solving Our Climate Crisis* (Alberta, Canada: Portfolio, 2021).

the U.S. global health presence. The U.S. commitment to global health represents the best of the American people.

Through that, my colleagues and I established the landmark program called Saving Mothers, Giving Life. This public-private partnership worked with the governments of Uganda and Zambia, and later in Nigeria, to dramatically improve care to mothers in labor, delivery, and during those first, tenuous forty-eight hours postpartum.

Then in 2016, after the U.S. presidential election, I decided not to go forward either in government or in a company. I wanted to work directly in an area that would clearly be under threat given the outcome of the election. And I wanted to do something big enough, especially when the challenges at that moment seemed so immense.

Big, Unlocking Moves

How do we tackle mounting challenges in a way that endures?

I take this question seriously and believe that the key to addressing many of today's challenges is to bring forward as much of the world's talent as possible. We do this by unlocking the energy, talent, and inventiveness of all people, especially those currently disenfranchised or oppressed who have been denied opportunity by the ways that power is organized and distributed within their communities.

Having access to good reproductive healthcare had, in a very fundamental way, enabled me to be a mother and a leader in companies, government, and my community. When I was invited to join Pathfinder, I found a new path to make this happen for other women.

Pathfinder centers sexual and reproductive health and rights at the heart of its work, unlocking the full potential of women, young people, and whole communities. We know that this work strengthens health systems; fosters community resilience in the face of droughts,

floods, and extreme weather brought on by climate change; and increases women's ability to make a living.

I came to Pathfinder because I have seen how much women matter in the alleviation of poverty, in protecting the environment, and in stopping the spread of disease. I have seen how devastating it is when women and girls have few rights and are treated inequitably by their society. I came to Pathfinder because I worry about the devastation of climate change and what that means for my children and grandchildren's generation.

I also came to Pathfinder for very personal reasons—including one I've yet to mention. The people of southern Africa paid for an important part of my education. Scores of men and women suffered in forced labor to create the wealth that led to the Rhodes Trust, which financed my scholarship at Oxford. I owe, and own, this debt, and my service at Pathfinder is one, albeit small, way of repaying it.

I take heart from the fact that for decades, Pathfinder has led sexual and reproductive health and rights programs that support every person, no matter who they are, to make the most critical decisions about how their lives will unfold. For millions of people, those decisions center around whether or when to have children. When more adults and young people have access to reproductive healthcare, we see real change in communities' abilities to address the challenges of our time. Pathfinders—the name we give ourselves—work closely with partners around the world to enact policies and run programs that acknowledge that reproductive health and well-being are central to building stronger societies.

In this book, my fellow Pathfinders share their stories and insights. We share how we have grown and changed as an organization—over nearly seventy years working in over one hundred countries—and how we are continuing to change so that the communities we work

in can achieve more of their goals. We share how important this work is to women and girls, especially today when we face so many global crises.

Two remarkable women, Tabinda Sarosh, president for South Asia and the Middle East and North Africa (MENA), and Lydia Saloucou Zoungrana, president for Africa, lead Pathfinder with me. In a sense, Tabinda and Lydia were born Pathfinders. From her earliest days, Tabinda heard her parents talk about human rights, especially women's rights, at the kitchen table. She saw her parents make decisions about their own work based on where and how they felt they could best elevate the human rights of all people. "In medical school," Tabinda says, "I combined my clinical orientation with a focus on gaps in care and gaps in kindness and compassion that made it hard for human rights to be realized." As she focused more and more on the rights of women, she worked globally at the intersection of healthcare and human rights, including her work against child marriage. This work naturally led Tabinda to leading efforts around women's and girls' well-being, given the challenges of food insecurity because of climate change. Prior to being appointed president, she led our work in Pakistan.

Lydia's father wanted her to follow in his footsteps and become a doctor, and her mother hoped that Lydia would follow in *her* footsteps and become a midwife. But Lydia had her own vision. She studied sociology, the study of the development, functioning, and structure of human society: "I call it the 'surround sound' of clinical medicine," she says. "So much of what we know in medicine does not get borne out in practice, because social structures and culture are more powerful." After watching her work for several years, Lydia's father and mother agreed that her work as a sociologist was a powerful way to improve the health of her fellow citizens in Burkina Faso. Lydia went on to play

leadership roles in family planning in East Africa before becoming our leader in Burkina Faso.

Together, the three of us share an understanding that this work is an ongoing struggle. It is always hard, and it is never done. The struggle shifts and changes with time and place. Power itself shifts and takes on new configurations.

The fact that human beings experience real trauma, hardship, and neglect every day is the reason that we must find our path together. No person, no single organization, and no single field or industry can do this work alone.

What matters most is our continued effort to carry out this essential work, doing what we can here and now. Tabinda, Lydia, and I have come together from diverse backgrounds with so much in common—leaders, women, and mothers with a common recognition of the need for big, systemic change to address the daily traumas experienced by so many of the most talented people in the world.

Interconnected Lives

Our world is profoundly interconnected. There may have once been a time when we could feel that we were separate from what happened elsewhere in the world, that we could protect ourselves without protecting others. But that time is long gone.

What we do today or don't do today to mitigate climate change in one part of the world causes floods, droughts, and extreme weather in other parts of the world. People left out of the world's economic progress and harmed by the disrupted rhythms of agriculture and access to water caused by climate change migrate at considerable risk to parts of the world that are wealthier and more secure. An illness that starts in one place sparks a global pandemic.

Now, think about the roles of women in response to these crises. Over and over again, it is a woman who scrambles to find food, water, shelter, and help for her children and her extended family. My mind turns to women in the North African Sahel desert where we work. We see them care for their families whatever comes: they grow and procure food, they gather water and other supplies for daily living, and they seek healthcare for their families. They are genius at developing ways of storing and managing food supplies in ways that suit local conditions. In a crisis, they are incredibly resourceful in understanding how best to adapt to changing circumstances. They embody the phrase, "Necessity is the mother of invention."

What if all these women were supported with good access to quality reproductive healthcare so that they could have the opportunity to choose the timing and spacing of children and thrive in pregnancy, labor, and delivery? And what if this meant that they could take up opportunities to complete their schooling, learn, and grow using their unique talent and capabilities? These well-supported women would be far more likely to be able to use their time, knowledge, and skill to contribute to their families, communities, and countries beyond the confines of meeting the basic needs of daily life. They could help their extended families and communities acquire the resources and services they need to be healthy and well. And so important, they could also better care for themselves and realize their full talents.

What I mean when I say that we need more mothers to be inventors is that we need more mothers to be able to be inventors.

As I see it, reproductive healthcare is about nothing less than human well-being and human flourishing. To put it otherwise, reproductive healthcare is not a stand-alone concern or a special interest; it's a precondition for sustaining and advancing well-being across the globe. Reproductive healthcare makes it possible for more of us to

fully participate in community life. But we can't genuinely encourage that participation without providing and sustaining services that allow people greater influence over how their futures unfold. I take it as my task in this book to confirm just that point by showing the ways that we have been engaged in providing and sustaining those services and by showing that we are poised to work in ways that can have even greater impact and more lasting empowerment of women and girls.

We well know that women are half the population of this world and that the world needs the intellectual and innovative capacity of women to address the challenges in front of us. Our work is to make it possible for all people to lay claim to their personal and collective power for their own sake and for the sake of us all.

PART I
What Was

We are all shaped by where we come from.

The people who raise us, the places that sustain us, and the powerfully good and difficult things that happen to us.

Mindsets, organizations, and movements all start somewhere, even if that somewhere is not clear—even if that somewhere is suppressed or ignored. This is how we end up in the nonsensical situation where women and girls—fully half of the human race—are not seen as the greatest source of talent and inventiveness in the world. That fact explains how global aid organizations so routinely shift decisions away from the very people who know so much about problems those organizations exist to address. The fact that all things have a lineage is how ideas that are fundamentally racist and unscientific take root in scientific and otherwise forward-thinking communities.

That all things have a lineage is also how we acknowledge the beauty and the power of where we came from. We see the visionary,

hardworking people on whose shoulders we stand today. We can do what we do today, because people before us believed in the full humanity and genius of women and girls. We work to create agile organizations that learn, adapt, and evolve to respond to today's challenges. We work to acknowledge the ideas that shaped our past while we recognize that all people should have the same sexual and reproductive health and rights, no matter the circumstances of their birth.

Looking at "What Was" powerfully underscores that it's time to do what it takes to unlock the talent and inventiveness of women everywhere. We must press forward. It is just, and the well-being of the world depends on it.

Pick Your Crisis

P ick your crisis. There are plenty to choose from.

Every day brings new challenges: weather disasters, war and terrorism, millions seeking refuge, increased costs of living, struggling healthcare systems, threats to democratic institutions, and the persistence of poverty and loneliness.

I could go on.

These challenges can't be addressed one at a time. They build on each other. Each challenge holds the potential to make other challenges worse—and often does. Trying to address them in isolation is not just a losing proposition. It's impossible.

To make things better for us and for our loved ones now and in the future, we have to find ways of addressing these challenges that are big enough, powerful enough, catalytic enough to make a significant difference. Instead of a one-part solution, we need a many-part solution. To solve a poly-crisis, we need a poly-solution. Instead of a single fix, we need a many-fix.

Whatever you care about, unlocking the energy, talent, and inventiveness of the world's women is your cause. Women are half of humanity, half of all the energy, half of all the talent, and half of all the new ideas in the world. Unlocking those capacities is big enough and powerful enough to be a many-part solution, a many-fix that can live everywhere.

There is a massive body of work documenting the unique contributions women make to addressing today's crises. It is worth reviewing that material—and we will do that in this chapter. But before we review that research and analysis, I simply want to say this. It is obvious. There is a prima facie case. And, if you stop and think, you already know it. You can already see it.

If you identify as a woman, you have experienced the unique talent, perspectives, and creativity you bring to your family, your community, and your work. If you do not identify as a woman, you have seen and benefited from the contributions of women around you.

If in your life, you spend time with women who have had access to education and reproductive healthcare, women who both care for their families and contribute to their communities, their professions, and their societies, think for a moment about what it would be like if they weren't there. If all that talent, energy, and all those good ideas were removed, we would be lesser, less capable, and less well off. When we don't use all the energy, talent, and inventiveness of the world's women, we lose. Alternatively, if you imagine a world where all women have the support they need to reach their full potential in life, what would *that* look like?

That would be transformative, world changing.

What you already know in your own lives is borne out in the research.

Name your crisis—and the research shows that when women and girls are engaged and empowered, everything is better.

- When women are active in their community and country, their engagement decreases the likelihood of violence and, when violence occurs, increases the likelihood of lasting peace agreements. For example, a study found a statistically significant relationship between the level of violence in a crisis and the proportion of female leaders involved. The greater gender equity, the less violence.[6]

- Research demonstrates that women who have their own income are more likely to invest in the health, nutrition, and education of their children and therefore improve national living standards.[7]

- Increasing the number of women elected officials reduces the number of human rights abuses.[8]

- Women in rural communities around the world are the farmers who grow, prepare, and distribute food. Giving women equal access to farming supplies and resources could reduce global hunger for up to 150 million people.[9]

6 Mary Caprioli and Mark A. Boyer, "Gender, Violence, and International Crisis," *The Journal of Conflict Resolution* 45, no. 4 (August 2001): 503–518.

7 World Bank, "World development report 2012: Gender equality and development," 2012; Gayle Tzemach Lemmon and Rachel Vogelstein, "Building Inclusive Economies: How Women's Economic Advancement Promotes Sustainable Growth," Discussion Paper. Council on Foreign Relations/Women and Economic Policy, June 2017.

8 Erik Melander, "Political Gender Equality and State Human Rights Abuse," *Journal of Peace Research* 42, no. 2 (2005): 149–166.

9 The State of Food and Agriculture, "Women in agriculture: Closing the gender gap for development," Food and Agriculture Organization of the United Nations, 2011, efaidnbmnnnibpcajpcglclefindmkaj/https://www.fao.org/3/i2050e/i2050e.pdf.

- A 2015 McKinsey Global Institute Study projected that full participation by women in global labor markets could increase global gross domestic product (GDP) by 26 percent within ten years.[10]

- Given that over 65 percent of all healthcare roles are held by women,[11] strengthening health systems depends on women's engagement as full partners. This is especially important in a pandemic.[12]

Rachel Vogelstein and Jamille Bigio sum it up best:

"Unlocking the potential of half the population is not just a moral obligation—it is an economic and security imperative. At a time when resources are limited, investing in women and girls is a proven way to bolster good governance, economic growth, community health, and peace and stability."[13]

10 Jonathan Woetzel, Anu Madgavkar, Kweilin Ellingrud, Eric Labaye, Sandrine Devillard, Eric Kutcher, James Manyika, Richard Dobbs, and Mekala Krishnan, "How advancing women's equality can add $12 trillion to global growth," McKinsey Global Institute, September 1, 2015, https://www.mckinsey.com/featured-insights/employment-and-growth/how-advancing-womens-equality-can-add-12-trillion-to-global-growth.

11 World Health Organization, "Value gender and equity in the global health workforce," n.d., https://www.who.int/activities/value-gender-and-equity-in-the-global-health-workforce.

12 Rachel B. Vogelstein and Lois Quam, "There will be another pandemic. Women can stop it," Council on Foreign Relations, February 2, 2021, https://www.cfr.org/article/there-will-be-another-pandemic-women-can-stop-it.

13 Jamille Bigio and Rachel Vogelstein, "Understanding gender equality in foreign policy," Council on Foreign Relations, June 2020.

So, how do we make this happen? As Pathfinder's president in South Asia and the MENA, Tabinda Sarosh says, "The most crucial thing we must do is make sure that every girl and woman has access, when she chooses it, to the reproductive healthcare she needs. No *girl* can achieve her full potential and play the roles that her family, her community, and her world need her to play if she has a child too soon. And no *woman* can achieve her full potential and play those roles if she cannot influence her fertility." Girls and women need more than reproductive healthcare. But reproductive healthcare is essential.

Your own experience may have taught you this. You may have feared a pregnancy when you missed a period or when your partner did. You may have feared not becoming pregnant when you hoped for a baby.

And yet, access to reproductive healthcare has always been controversial. Across the United States, access to safe abortion has dramatically reduced in the wake of the Supreme Court decision on *Dobbs v. Jackson*.[14] Across the globe, there is constant agitation and activism aimed at stopping women and girls from accessing reproductive health services. Girls continue to be forced into early marriage, and women are routinely blocked from making their own choices about when and whether to have children. At times, I envy my colleagues working to stop the spread of tuberculosis or malaria, because they face so little controversy. There are not well-organized, heavily funded organizations that oppose tuberculosis or malaria prevention. But, as most of us well know, there are well-organized, heavily funded organizations that oppose reproductive healthcare.

Hundreds of millions of women and girls have been able to complete their education, contribute to their families and communities, and care well for their children, because they had access to good

14 Kelly Baden and Jennifer Driver, "The state abortion policy landscape one year post-Roe," Guttmacher Institute, June 15, 2023. https://www.guttmacher.org/2023/06/state-abortion-policy-landscape-one-year-post-roe.

reproductive healthcare. You may be one of these women. You may know one of these women.

Millions of women have survived their pregnancies, because they were able to wait to have children until their bodies were mature enough, or they were able to avoid having children when they were older, or they were able to space their children so that they could be healthy. More women survived pregnancies, because they were able to labor and give birth in a safe location with skillful practitioners around them. More women survived their pregnancies, because they were able to receive a safe abortion rather than attempt an abortion at their own hands or in another unsafe way. And more women survived unsafe abortion, because they were able to get post-abortion care with well-trained help. You may be one of these women. You may know one of these women.

No matter when and where, from the earliest times to today and across continents and societies, the advancement of women has always been controversial. Many of us know this from personal experience of painful moments and perhaps even heartbreaking injuries.

Women are expected to deal personally and privately with the hardships and trials that result from their fertility, whether that's menstruation or menopause, preventing or enabling pregnancy, experiencing a difficult pregnancy, or giving birth. From adolescent girls leaving school because they don't have adequate menstrual supplies to women giving birth unattended, women and girls are regularly neglected when it comes to meeting their basic needs.

The work we do is part of a movement, a long-term undertaking to continue making measurable changes that increase women's sexual and reproductive health and rights. Progress requires persistence in the face of opposition and even in the face of serious setbacks. We never give up, even when the challenges seem insurmountable.

Pathfinder Profile

AMINA DORAYI
Pathfinder Leader in Nigeria

If one life could tell the story of Pathfinder's work and purpose, it might be that of Amina Dorayi, Pathfinder's leader in Nigeria.

Born in Kano State in northern Nigeria, the first of nine children, Amina was a young girl with big dreams but no role models to help her chart her path. She wanted to be a doctor. From the moment she heard a doctor speak at her secondary school, Amina says, "I knew what I wanted to do, but not how to do it. I had heard a lot about women dying in labor when I was growing up, and it was powerful to think that I could help save women's lives. I wanted to do that." While there was no one in her family who had gone to university to study and work in medicine, her father was supportive of her dreams.

Fortunately, Amina had the kind of pivotal experience of empowerment and skill development as a young person that we know at Pathfinder makes such a difference. At her secondary school, she was invited to serve as a health prefect supporting the school nurse. Then, at Ahmadu Bello Zaria University in Kaduna State, where she studied medicine, she dedicated herself to supporting the lives and well-being of women. Serving in hospital obstetrics wards, Amina helped women safely deliver their babies and worked so that women could live after they had received an unsafe abortion elsewhere.

A Muslim herself, Amina has been a pivotal force in Pathfinder's long-standing work with Islamic leaders, including the areas in northern Nigeria where Boko Haram is based, to improve the

health and well-being of girls, women, and families. This work has resulted in support from imams and the development of Islamic materials on family welfare, including family planning.

Amina credits family planning with the fact that she brings her energy and talent to improve the lives of millions of women in Nigeria and to serve as a role model for girls in Kano State and beyond. Each of her pregnancies was different, a reality that emphasizes why women need support and access to full prenatal, maternal, and antenatal services in every pregnancy. In her first pregnancy with her daughter, she experienced high blood pressure due to the dangerous condition of preeclampsia. In her second pregnancy, she had a chronic, disabling cough that caused hospitalization, though the underlying cause was never found. The cough departed with the birth of her son. In her third pregnancy, the cough returned until she experienced a miscarriage. Her fourth pregnancy with her second son was uneventful.

Amina's three deliveries were also difficult, and she knows that if she had delivered in a mosque, a church, or in a home without a skilled provider, as so many Nigerian women do, she would not have survived. After each of her children's births, she hemorrhaged badly.

From both her personal and professional experiences, Amina decided to organize sustained support for better services for women. She called on fellow Nigerian women who had benefited from good access to reproductive and maternal services to step up and help other women and girls. She organized groups of women lawyers, women journalists, and women religious observants to build support for women's reproductive healthcare services across Nigeria.

Her three children, now growing into adulthood, have a remarkable role model in Amina: a mother, an inventive collaborator, a fighter for us all.

Lydia Saloucou Zoungrana emphasizes that some of our most pathbreaking efforts are focused on the sometimes-slow work of changing minds, changing ideologies, and eventually changing widespread policies and practices. She says, "We not only can but do help clear the way for access to reproductive healthcare to be embraced and no longer seen as controversial. To do this, we work with the powers that be within a given community, whether that power is in the hands of religious leaders, government officials, mothers-in-law, teachers, or other influential people. Local leaders and influencers help pave the way for access to reproductive healthcare." Our role is to help launch and sustain the kind of initiatives and conversations that make this possible.

In fact, generating those conversations with religious leaders is often critical to what we do. We respect the influence they have and the leadership roles they play. Many Pathfinder leaders are also religiously observant and share a deep understanding of the role that faith plays in our work.

Ritah Waddicombe, our leader in Uganda, speaks to the strength of our work with religious communities. "In Uganda, we work extensively with Christian ministers and Islamic religious leaders to create the enabling framework essential to increasing access to life-saving reproductive healthcare services."

Religious leaders are interested in saving the lives of women and girls in their communities, so we have a shared goal. What is often not recognized by those same leaders is the actual situation for women and girls and the potential to make significant improvements. Often, we suggest undertaking an assessment or analysis

of the situation in a community. For example, what is the experience of pregnant women? Are women dying as a result of their pregnancy, and why? This analysis invites a broader and deeper conversation.

Conducting a community assessment also invites people to voice their beliefs and concerns. Following up on that assessment by engaging people's beliefs and concerns with information about reproductive healthcare issues in their community can lead to a shared understanding of the situation and can create an opening to focus on multiple dimensions of the challenges faced by a community.

For example, we might share with religious leaders our finding that in their own community, of the two hundred pregnant women, there were five who died. We also share why they died: they were delivered without a skilled provider and in a church or mosque or at home; when complications developed, they couldn't get the care they needed quickly enough; or it might be that a woman died in a hospital, because there were no blood products available to meet her needs when she hemorrhaged or no provider with the skills to perform an emergency C-section.

Shared understanding of the actual experience of women and girls and the impact of their well-being on their loved ones and the broader community is both the fuel needed to work together on solutions and the basis for concrete prioritization of solutions. Priests, imams, and pastors can decide to encourage women to deliver in hospitals instead of churches or mosques and assure them that they will be protected by God in a hospital setting. Hand in hand with Pathfinders, religious leaders can make a powerful case to their governments to improve local health facilities so that

services are available around the clock and supplemented by additional mobile community resources.

What binds community leaders to the solutions they help generate is that, ultimately, they do not want the women in their communities to die or suffer needlessly. They recognize that, as community leaders, they are accountable for the lives of their community members.

Our leaders in Nigeria tell a story that captures just this sentiment. A group of imams were in a conversation with trusted medical professionals they knew well, including an obstetrician/gynecologist and a public health physician. We were a part of those conversations, and shared the number of women in the community who had died as a result of their pregnancy, the number of young girls who had become pregnant, the number of girls who left school because of pregnancy, the number of women and girls who suffered from unsafe abortion. When the imams, at first, questioned the validity of this information, we dug deeper, providing further details about specific hospitals. This opened up a compelling conversation that allowed community truths to emerge. People started to share stories and wanted to find solutions. Everyone gathered there shared an interest in stopping the suffering and dying.

In this way, we appealed to community leaders, reinforcing the trust their community has given them and the accountability that comes from that trust. These problems are their community's problems, and those affected are their sisters, daughters, neighbors, and fellow congregants.

Once specific misunderstandings were addressed, the imams became champions for Pathfinder's work. They traveled with our team to Bangladesh to discuss contraception and family planning practices with religious leaders there. And they reached out to the

local health authorities and others to make sure that accountability and ownership are held at every level.

Pathfinders may see opportunities for offering specific kinds of help, but the sustainability of any effort requires that it become a community project. It's about the responsibility that these religious leaders hold for the well-being of the women and girls living alongside them.

Sustained Achievements

In Ethiopia since 2006, we have partnered with the ministry of health to roll out youth-friendly sexual and reproductive health services at 423 health facilities. The Ministry of Health since established its Adolescent and Youth Health Strategy and scaled this model nationally. This massive effort included training 39,000 peer educators and 12,000 service providers on youth-responsive services, with more than eight million young people having received these services and twenty-five million young people having received information about sexual and reproductive health. The rollout of services was based on lessons learned from the strong program implementation of Pathfinder Mozambique multisectoral youth program. Given our reach and network in Ethiopia, the Ministry of Health has relied on Pathfinder for support with sustaining healthcare during both the COVID-19 pandemic and the civil war.

In Mozambique, the government welcomed a program started by Pathfinder that provides information on reproductive health and the prevention of HIV to young people via text message. The program reached more than twelve thousand young people during a decade of Pathfinder support and thousands more since. The government

spread the message about the program during the pandemic to reach Mozambicans of all ages with information about COVID-19.

In India, Pathfinder worked on a groundbreaking program which supported millions of young couples and adolescents to adopt healthy reproductive behaviors and tackle social norms that pressure them to marry and have children before they are ready. Young women who took part in the program married almost three years later than those who did not. The program trained more than one thousand frontline health workers and worked with twenty local implementation partners and the Bihar government over a period of twelve years, resulting in a highly sustainable model that other organizations have sought to replicate locally and globally.

What all of us Pathfinders know from our years of accumulated experience is that the best assessment of what needs to be done within a community doesn't come from judgments made by people outside that community looking in. We have worked hard to learn how we can set the scene for informed discussion and decision-making at the local level. Over and over again, we experience the magic that occurs when people gather together and give voice to the open secrets of a community, such as "No one spoke about why she died, but everyone knows she tried to give herself an abortion." Every one of them, just like every one of us, knows a young girl so smart, so promising, whose life is utterly changed by a pregnancy that comes too soon or comes in the wake of a sexual assault. And everyone knows that, too often, the man involved has simply gone on with his life unchanged. We contribute to community reflection on these shared experiences and imagine along with them opportunities for a new path.

What we know from all our years of deep learning is that the opposition to ensuring sexual and reproductive health and rights—

whether overt or unstated—will never completely cease. New chal-
lenges to our progress will arise, sometimes in configurations we didn't
know to expect. What matters most, now and into the future, is our
ongoing responsibility to keep helping women and girls who need the
resources, services, and tools that enable them to prevail. And the only
way we can effectively do this on a global scale is by working *with*,
not *for*, their communities.

Working with and Not For

O n a beautiful, sunny day, Tanzanian Pathfinders and col-
leagues were getting to work, and there was a lot of work
to do.

Every year in Tanzania, more than one million women have
an unintended pregnancy, with nearly four in ten of those women
ending their pregnancies with an unsafe abortion. That's over 400,000
Tanzanian women a year enduring unsafe abortions, because they
lack access to quality reproductive health services. Of the Tanzanian
women who do give birth, nearly three-quarters of a million do so
outside of a medical facility—often at home, or in a church, or in a
field.[15]

15 Jonathan Marc Bearak et al., "Country-specific estimates of unintended pregnancy
 and abortion incidence: A global comparative analysis of levels in 2015–2019," *BMJ
 Global Health* 7, no. 3, 2022, https://gh.bmj.com/content/7/3/e007151.

Nearly a quarter of Tanzanian girls are either pregnant or have become mothers by age nineteen.[16] These young women are much less likely to finish their education, and they and their families are much more likely to struggle with financial insecurity throughout their lives.

Our Tanzanian Pathfinders see a different future for Tanzanian girls and women. They see a bright future where all women and girls have the opportunity for excellent access to reproductive healthcare and the future it helps them create. That's the vision that inspires our Tanzanian team each day, including on that bright sunny day when they were beginning their journey through a national park region—an area filled with rock outcroppings, trees, and foliage, near Lake Tanganyika—to reach a community living in an isolated area.

That's when it happened. The magnificent creature appeared—a brilliant, massive cobra stretching up from the rocks, reaching straight into the sky. Appearing from out of nowhere, the cobra was now the commanding presence.

Everyone stepped back.

Plans changed.

Perhaps nothing better illustrates the importance of local knowledge than meeting a cobra on one's path. Only someone present at the scene can gauge the threat it poses and respond. No one in a global headquarters, a country headquarters, or even a regional headquarters—no matter how talented, highly educated, or committed—can register the cobra on the path in the same way as those present on the scene. One must be there to make sense of things, to assess the better, alternative paths.

16 United Nations Population Fund, "Tanzania fact sheet: Teenage pregnancy," accessed July 2023, https://tanzania.unfpa.org/sites/default/files/pub-pdf/factsheet_teenage%20pregnancy_UNFPA_14oct.pdf.

In the work to ensure that everyone, everywhere can access safe reproductive healthcare, there are always cobras in the path—barriers and threats appearing out of nowhere, sudden and startling to some while others familiar and old as the path itself.

Lived experience can offer insights as great or greater than the world's finest education. Here's just one example.

Tore Godal, a Norwegian physician and one of the world's most accomplished global health innovators, tells a story about his time as a young physician working in Lyngen, a municipality in Norway well above the Arctic Circle. In those days and still today, Lyngen doesn't have its own hospital. A trip to the nearest hospital takes a substantial drive over a mountain and travel by ferry across fjords to the city of Tromsø.

As a new doctor working on call in the region, Tore was called out one evening by a taxi driver who had come to his hostel with a pregnant woman in labor. After examining her, he told the taxi driver to take her to Tromsø. The taxi driver was reluctant and wanted Tore to follow. Tore agreed and said that he would return once they reached the halfway point. Tore felt confident that the pregnant woman could make the trip all the way to the hospital.

But before they reached the mountain top, the taxi driver stopped and asked Tore to join them in the taxi. There, the woman was in the process of delivering. So, Tore helped her deliver in the taxi, then stayed with her there, and clamped the umbilical cord. A baby girl was born in the taxi, and the trio arrived safely at the hospital in Tromsø.

Who could best predict the outcome in this case: a physician who was well-trained and had examined the patient or a taxi driver who, over the years, had made this same trip with many laboring women as his passengers?

In this instance, it was the taxi driver. Not only had he done this before, but he also knew that the woman had delivered eight babies before this one, and he knew the woman's experience with her previous deliveries.

Tore carried this lesson into his work in Norway, then at the World Health Organization, and as the first leader of the Global Alliance for Vaccines and Immunization (GAVI). That lesson? Respect the expertise that comes from the long-lived experience of people who must negotiate their environments every day. Respect their capacity to navigate that experience.[17]

Pathfinder's Mengistu Asnake applies this same principle while leading our work to improve health systems across Ethiopia. Mengistu sees it like this: "I trained as a medical doctor, and we are always saying that the patient is the best book. You read that book very carefully to learn everything you can about how the patient is feeling." This marriage of training and listening to experience is a powerful combination.

Mengistu takes this insight a bit further: "There's a difference between reading and experiencing. Listening to others' stories helps us imagine how it might be for someone else. But experience can deepen that ability."

That's why our organization looks to Pathfinders whose lived experience mirrors those in the communities where we work. Mengistu gives a personal and vivid example:

> I practiced medicine before becoming a Pathfinder country
> director. For quite some time in my practice, I was not
> granting sick leave for any patient coming to me with malaria.
> That was because malaria was endemic—like the common

17 Conrad Keating, *Tore Godal and the Evolution of Global Health* (Oxfordshire: Routledge, 2023).

cold, everyone seemed to have it. Then I, myself, caught malaria. I was back visiting my family, and my elder sister was pregnant at the time. But I felt so sick that wherever we went, I was the first one of the two of us to take a seat, rather than giving it to my pregnant sister. After that experience, even if a patient didn't ask for leave when they had malaria, I granted them a minimum of three or four days.

The same lesson now guides Mengistu's strategic and project-based decisions: "Just as my experience of malaria made me better able to meet the needs of my patients with malaria, so too does sharing the experiences, the language, and the culture of the communities we serve help me better meet the needs of those communities."

That should be no surprise to many of us who see the opposite phenomenon play out in our own lives and work environments. We know how bad it feels to be ignored or not listened to when we have well-earned insights to share. We feel the stress of having to navigate systems that function without seeming to have a clue about how life really is for us.

Too many global health and development organizations make decisions at the farthest location from impact, thousands of miles away in the capital cities of Europe and North America. No matter how well-trained, terrific, and dedicated those people are, they're still not present when the cobra comes along. Without acknowledging the authority of local expertise, health and development organizations simply cannot be resilient enough in the face of all the world's challenges—prejudice, weak infrastructure, violence, extreme weather— or any other cobra on the path.

I make this point knowing full well the historic pull of colonialist organizational models and mindsets that perpetuate the perception that organizations located in North America or Europe are in the best

position to offer their expert assistance. These models and mindsets are well-entrenched; shifting them means that some powerful people lose power, and some talented people see their roles shifted to other talented people elsewhere in the world.

And power is never shifted without difficulty.

Working *with* and not *for* people is something we constantly recommit to doing. My colleague Mengistu puts it best: "Our courage at Pathfinder, to really stay in place and continue to serve, is a very important part of our history. That we work toward establishing real partnerships—not just a giving and receiving relationship, but *mutual partnerships*—enables us to earn trust and overcome suspicions. We Pathfinder leaders are in the same boat as the people in a given village or region. We work together."

Mengistu shares, "For example, in one community, women were in most cases choosing to go through labor and delivery at home, despite the fact that there was a local facility where they could go to deliver. As a result of not being in a proper facility, when complications arose, many of these women died. To get to the bottom of why this was happening, we had to go out into the community and talk with the women and the community leaders."

Pathfinders learned that women chose not to go to the area facility to give birth because there was no power in that facility at night. And because there was no power, the building could not be secured at night, so the service providers would work until dusk and then go home. When women experienced complications during a pregnancy at night, these women knew that there was no one at the facility to help. We also learned that the facility was missing necessary tools—on any occasion, whether day or night, there might be no safe blood or appropriate instruments for delivery.

The solution in this case came down to clarifying the extent of the problem and then assigning roles and responsibilities to resolve it. Instead of using a model that involves buying ambulances and hiring drivers, or supplying power, security, and proper tools to the local facility for a period of time, the Pathfinders in that community asked its leaders: How do you all move around? What are the resources in your community that could support women who require emergency care? How can *you* ensure that the facility has power and security?

Instead of working only with practitioners at the highest levels of healthcare—in a teaching hospital or a general hospital, for example— we always go to the most local level of the health system. This allows us to reach the most vulnerable and truly leverage the resources that the community brings to strengthen whole systems. Starting at the most local level means that we are closer to the people most in need and to the key influencers in any given community.

When I say that our leaders live, breathe, and work directly with the people they serve, I mean that they understand the extent of particular issues, the real possibilities for solution, and they know who they need to partner with to achieve meaningful results. As our long-serving Kenya leader Pamela Onduso puts it, "The core insight is this: Pathfinding means understanding and respecting the cultures and norms of the community we serve, coupled with strategic partner- ships with public, private, faith-based and ecumenical stakeholders to achieve sustainable development. That's how our country programs work."

In other words, we cannot address the kind of issues we are dealing with by coming in from outside. We have to understand the culture, the nuances, and the very particular circumstances.

Historically, global health and development organizations have too often worked from the perspective that they know best and have

offered ready-to-go solutions believed to be applicable across communities and regions. From this perspective, these organizations simply needed to gain access to communities so that they could efficiently distribute products and services. While many organizations have shifted away from this approach, it is still all too common that "coming in from outside" is a tacitly accepted model.

But we have to tackle these challenges "from the inside." That's because you won't know what to do in response to a cobra if you have never met one along your path.

Pathfinder Profile

COLLIN MOTHUPI
Board Chair, 2021–

Healthy organizations constantly change as they innovate and respond to the dynamic circumstances around them. At times, this means taking an entirely new, unconventional path, and, at other times, this means keeping hope alive when hope seems far removed. Pathfinder's board chair Collin Mothupi, elected in November 2021, offers Pathfinder a lifetime of innovation and hopefulness.

Collin is a healthcare executive with leading-edge innovations in children's hospitals and data analytics to improve patient care. One example of his work stands out for me because it is so unexpected, so nonlinear. He had to explain it to me twice before I fully grasped it.

Collin and his colleagues recognized that children with congenital heart defects were now living longer and, as a result, lacked the right care when they reached adulthood. As adults, they were treated in cardiology departments with patients who had developed heart conditions in adulthood. While these heart conditions presented in some similar ways, the different causes and disease trajectories required different treatment. These adult patients with a heart condition from childhood did not receive that care.

What did they do? They developed the first Adult Congenital Heart Defect Program where adults with a history of congenital defects were treated in a pediatric hospital—totally original, unprecedented, and now a best practice model and standard of care across the United States. Every American pediatric hospital of note now has such a program.

Collin's vision and innovative touch are central to his service as chair of the Pathfinder board. He has an ability to see our new opportunities even if they are not obvious. Especially if they are not obvious.

Collin also brings experience in board dynamics and best practices through his board service at Sheppard Pratt, one of the largest American providers of mental health services, renowned for innovative treatments in behavioral health. This board experience has been valuable for Collin both because mental health and sexual and reproductive health are misunderstood categories of need and because both organizations combine a broad health system brand with a local presence.

A South African citizen, Collin has lived in three Pathfinder countries. Born in Uganda, he attended school in Tanzania and Kenya. Collin's experience living in exile, holding a United Nations (UN) refugee passport, during the period of apartheid in South Africa manifests at Pathfinder in his relentless optimism. I have asked him how this can be. Wasn't it hard growing up outside of your home country because of the racism of apartheid when you didn't know if things would ever change? Didn't you feel despair?

Collin shares that there was a sense of hopefulness in his home as at any time, there were twelve to fifteen South Africans recently exiled seeking support. While this made for a crowded home, there was a constant sense of hope in action as his family helped fellow exiled citizens find housing, work, and a home-cooked meal. I see Collin translate this experience, as he chairs our board, into optimism in the midst of dynamic change. Collin does not spend time or energy yearning for the past or what might or should have been. He recognizes what is happening and uses his energy, talent, and inventiveness to succeed—and help us succeed—in new settings.

Collin tells the story of his experience arriving in Tanzania to attend high school. Shortly thereafter, his father assumed new responsibilities as a liaison to the United Nations requiring him to move back to Kenya and sending Collin to live with a host family he had never met that was connected to the Pan Africanist Congress (PAC). Where others might tell a story focused on the stresses of unforeseen change at such a tender age, Collin always shares this detail of his past with an easy smile and a memory of all the new possibilities created by this unanticipated shift in circumstances. I see him take this same approach when we discuss changes in a country program due to a coup or flood. And as we put our updated country-led strategy in place shifting leadership, roles, and resources from the United States to Africa, South Asia, and the Middle East, Collin is both sensitive to the hard moments that arise as these shifts bring disruption to our American Pathfinder colleagues and optimistic about the possibilities accompanying this change.

Today, he enjoys success as a health technology executive navigating the rapidly changing health sector, focusing on data, analytics, and performance metrics to improve services for patients. In his work, he again responds to the world as he finds it building impact during dynamic change. In difficulty, Collin sees the light of opportunity shining through the cracks.

He adapts and leads the board in helping us adapt. During his tenure, all the major donors in global health and development have shifted to a model preferring investment in country-based organizations rather than international organizations. Donors are also seeking to invest in women's economic empowerment, women's role in climate resilience, and broader health systems strengthening while incorporating sexual and reproductive health in these goals.

WHO RUNS THE WORLD?

We applaud these changes and were early adaptors in shifting to a country-led organization and this broader approach uniting reproductive health services with women's empowerment and community benefits. Collin, as board chair, has helped us embrace these changes with speed and urgency.

As the first African board chair, Collin has presided over a period where we have appointed our first African and South Asian presidents, our first African corporate secretary, and so many other key roles. Collin is our board leader as we make permanent our shifts in the country-led strategy appointing new leaders and shifting the accountabilities, strategy, and funding flows.

CHAPTER THREE

Turning a Clear Eye toward the Past

I f this book had been written some time ago, it would have led with the story of a doctor from Massachusetts, the heir to a family fortune—Pathfinder's founder, Clarence Gamble. That book would have begun by praising his vision, energy, and courage in establishing Pathfinder, noting both his global travels and his personal financial support for the organization's mission.

Today, we tell a different story. We tell the stories of Pathfinder leaders who are from Africa, South Asia, and the Middle East.

We also tell a fuller, more accurate story about Clarence Gamble. His approach, like that of his peers in the early family planning and environmental movements—Margaret Sanger, Marie Stopes, John Muir, and others—was rooted in a vision of population control and eugenics. Eugenics, coined and popularized by Francis Galton in 1883, is a deeply racist and unscientific ideology and set of practices that seeks to alter the genetic quality of human populations for human

race "betterment."[18] Proponents of eugenics wanted to reduce the number of people they deemed unfit or undesirable and to encourage the reproduction of people they deemed fit. Since the field of eugenics is inherently white supremacist, racist, classist, and ableist, it targeted anyone who did not meet a Eurocentric standard of appearance and ability, and it stigmatized poverty and mental illness. European and North American colonial powers adopted eugenic policies, making it legal to violate the human rights of certain populations. And in 1927, the U.S. Supreme Court decision in *Buck v. Bell* set a legal precedent for forcibly sterilizing people in public institutions.

It wasn't until the end of World War II that the U.S. government and eugenic advocates fully turned their attention outside the country's borders.[19] These forces made population control an international movement and acted to limit the birth rate of non-European groups of people through coerced, forced, or unconsented contraception and sterilization both at home and abroad.

Eugenicists within the global family planning movement believed that healthy white people should have children and that Black and Brown people should not. Correspondingly, they believed that experts in reproductive health should make the most intimate and personal decisions for the women and men who relied on their services and their medical expertise.

It is heartbreaking to acknowledge the implications of this vision—to consider that the most private and fundamental decisions about one's own body and life could be made by someone else, let

18 Natalie Ball, "Galton, Sir Francis," n.d., accessed June 5, 2022, https://www.eugenicsarchive.ca/connections?id=518c1ed54d7d6e0000000002.

19 Alexandra Stern, "Population control," April 29, 2014, accessed May 29, 2022, https://www.eugenicsarchive.ca/encyclopedia?id=535eed6a7095aa0000000249&view=reader.

alone someone more powerful and from a different and wealthier country.

It is also heartbreaking to imagine a different story. In that story, the early family planning movement could have focused simply on ensuring women's freedom from the life-threatening, high-risk realities of repeated pregnancy, miscarriage, unsafe abortion, and unsafe labor and delivery. They could have done this by addressing women's need to be informed about options for living healthier, fuller lives and then let women make their own decisions.

But the early family planning movement charted a different course. Its actions included forced sterilization of women and girls, the insertion of intrauterine devices (IUDs) without ensuring understanding or gaining consent, and experimentation with new forms of contraception—also without consent. Gamble's efforts regarding birth control were part of what he publicly called the "great cause" to solve what he privately described as "the population problem."[20] Like Margaret Sanger, he believed that populations with high birth rates were in need of rescue.[21] His "great cause" came at a very high cost. Gamble's work and philanthropy infringed upon people's right to reproductive freedom.

Some would excuse the views shared by these leaders and movements arguing that they were typical of their times. But in every time period, at every moment, there are people who envision a more just and equitable world. The 1792 text *A Vindication of the Rights of Women*, for example, presents a just vision way ahead of its time. Its author, Mary Wollstonecraft, died giving birth to her daughter, Mary

20 Clarence Gamble papers, 1920-1970s (inclusive), 1920-1966 (bulk). H MS c23. Harvard Medical Library, Francis A. Countway Library of Medicine, Boston, MA.

21 Robert Latou and Clarence James Gamble Dickinson, *Human Sterilization: Techniques of Permanent Conception Control* (Baltimore: Waverly Press, 1950).

Godwin Shelley, the author of *Frankenstein*, who herself experienced repeated difficult pregnancies and miscarriages.[22]

More than thirty years after Gamble established Pathfinder, our organization joined with other reproductive healthcare organizations to chart a new course focused on adopting a rights-based approach toward reproductive health, family planning, and population growth. New frameworks, regulations, and policies regarding informed consent and human subject research were enacted by international and U.S. agencies.[23] These changes were reinforced in the 1994 International Conference on Population and Development (ICPD), held in Cairo.[24]

As Dan Pellegrom, Pathfinder's CEO for twenty-seven years, notes, "I often say that Cairo was the turning point for this movement, because it simply, but vitally, put women at the heart of reproductive health care and family planning. But Pathfinder had been doing exactly that for a long time before Cairo."

There were several members of Pathfinder's Board of Directors in the U.S. delegation to the Cairo conference. Included among them was Joe Wheeler, a central figure in the formation of the U.S. Agency for International Development (USAID), an instrumental USAID Mission director in Pakistan in the 1970s, and a founding member of Pathfinder's Presidents' Council in 2020. The Kenyan pediatrician, Florence Manguyu, who delivered an address at the Cairo conference, went on to serve on the Pathfinder Board of Directors.

22 Charlotte Gordon, *Romantic Outlaws: The Extraordinary Lives of Mary Wollstonecraft and Mary Shelley* (New York, NY: Random House, 2016).

23 University of Missouri, Kansas City, Office of Research Services, "History of research ethics," https://ors.umkc.edu/services/compliance/irb/history-of-research-ethics.html.

24 United Nations, "Cairo declaration on population and development (ICPPD)," September 4, 1994.

At the conference, a rights-based agenda focused on women's empowerment became the global agenda, with the ICPPD Plan of Action statement: "Advancing gender equality and equity and the empowerment of women, and the elimination of all kinds of violence against women, and ensuring women's ability to control their own fertility, are cornerstones of population and development-related programmes."[25]

One of the best examples of the power of this shift took place in Vietnam. In the early 1990s, Pathfinder's then-CEO Dan Pellegrom traveled to Vietnam to amplify a rights-based approach. As Dan tells it, Pathfinder's argument was essentially this: "You'll get much better results if you provide high-quality voluntary family planning services and treat patients with care rather than offering them incentives to manipulate them into limiting the number of children they have. Treat women not as the object of a public agenda but with the appropriate health care that enables them to make their own decisions."

Long-serving Pathfinder Kate Bourne, initially living out of the old Army Hotel in Hanoi, worked with Vietnam's Ministry of Health and other partners to expand this high-quality, accessible, and rights-based approach to reproductive healthcare in four carefully selected provinces. In each province, Pathfinder and its partners trained staff, funded improvements to facilities, installed up-to-date equipment, and went to work assisting women. These caring policies and services were well received in Vietnam. Women and their families were offered the opportunities to make their own choices, and the Vietnamese government, with the support of its partners, expanded these services.

25 Programme of action, adopted at the International Conference on Population and Development, Cairo, 5-13 September, 1994, published by the United Nations Family Planning Association.

In the past several years, and like many other organizations, we have looked back to reflect on this decades-old shift to a rights-based approach and to grapple with the many injustices that remain in reproductive healthcare.

Where Gamble elected to make decisions for others, we recognize that the only person who should make a reproductive healthcare decision is the person most directly affected by it. Only that person should decide who to consult—whether that's a doctor, nurse, midwife, community health worker, parent, in-law, religious leader, or others—and what to do as a result. Our work is informed by the reproductive justice movement, which has shown that the existence of legal rights to reproductive care is meaningless when power inequities continue to exist in communities. People's ability to determine their own reproductive trajectories is directly linked to institutional, environmental, cultural, and economic factors far in excess of individual choice and access. Today, this idea is encompassed by work on behalf of reproductive well-being, which holds as its goal "that all people have equitable access to the information, services, and support they need to have control over their bodies, and to make their own decisions related to sexuality and reproduction throughout their lives."[26]

We knew that we had more work to do. That started by reckoning with our past and the eugenics vision of our founder. Although Clarence Gamble's words and actions in this area were well documented over decades, Pathfinder had not taken steps to come to grips, both internally and publicly, with this reality during that time period.

If I could do one thing differently in my tenure, I would have acknowledged Clarence Gamble's legacy the week I arrived. No, better

26　Power to Decide, "What is reproductive well-being?" https://powertodecide.org/reproductive-well-being.

yet, I would have thought to discuss this with the search committee while interviewing to lead the organization.

In June 2020, we launched the serious work of looking at our own history. In this, the actions of Planned Parenthood in addressing the eugenics legacy of its founder Margaret Sanger were important to us. We launched our own internal legacy and racial justice process to review the impact of Clarence Gamble's well-documented views on eugenics as they related to Pathfinder. As part of our legacy work, we commissioned an independent review of Gamble's activities and statements at Pathfinder, reviewing publicly available information and research as well as communications and archived materials internal to Pathfinder. And we donated Pathfinder's archives from the period of the Gamble family leadership to the Francis A. Countway Library of Medicine at Harvard University, making the collection available to researchers.

In April 2021, we issued a statement indicating how our research into our organization's history clarified our path forward:

> In our efforts to advance women's autonomy and informed choice, we have built our organization on a foundation of human rights and racial justice. But Pathfinder cannot truly lead the transformational social change at the heart of our mission without recognizing the harm that Dr. Gamble's personal views and actions caused to the very communities we serve. Nor will we content ourselves with mere recognition of the past: we are committed to working in concrete ways toward a more just future.

We shifted decades ago from one path to another, from a model steeped in colonialism and racism to one based on deep respect for human rights. And we have continued this shift by looking back at the legacy of our organization's founder. In so doing, we are building a more effective and just Pathfinder organization at the same time that we are building more effective and just communities.

We don't follow the path Clarence Gamble and his American and European peers laid by imposing onto African and Asian women, men, and young people decisions based on their own beliefs and cultural assumptions. Instead, we honor the leaders at Pathfinder and in our sister organizations and movements who cut a different path, recognizing that the use of reproductive healthcare must always be voluntarily and freely chosen.

This is the path we are walking.

What I most appreciate—what I love—about Pathfinder is the way that as an organization, and as individuals, we are committed to learning and changing. Together, we are continuously cutting a path by walking forward—turning a clear eye toward our past, never resting on our accomplishments, and always pausing to determine how we could do better.

What that means, of course, is that we *can* always do better.

PART II
What Is

We live in a world where the opportunity for women and girls to live up to their full potential is contested everywhere. This reality is a dangerous one—not only for women and girls but also for all the people who depend on them and for all of us seeking a better world. The effects of climate change that threaten extreme weather, water shortages, and food insecurity demand solutions in every place in the world and in every part of society. We can't succeed against this threat if we leave half of all humanity—half of all our talent, energy, and inventiveness—at home. And yet we are doing just that today.

To overcome our world's cascading challenges, we need inventive solutions. What we've done in the past won't work—it's not enough.

If necessity is the mother of invention, as the saying goes, we truly need more mothers—more women—to be able to be inventors.

Technology, in its mainstream, digital, and artificial intelligence forms, has a role to play in creating a future where the intelligence

and insight of women can provide groundbreaking solutions. But we risk a future where these tools fall into the same pattern where women and girls are excluded from their use.

It's about time we change *what is*.

At Home and Abroad

T he ambulance ride had begun. Two hundred miles left to go. A young woman lay in the back trembling as the rig bumped along a rutted road slippery from heavy rain. Fields of corn flashed by as they drove.

It was 200 miles to a clinic that could help her. She was expecting her second child, and her situation was grave. Wanting to be closer to her family and the comforts of home, she tried to arrange for care at a hospital nearer to where she lived. She had never spent time in the city where the ambulance would take her. She would miss the home cooking and the comfort of being in a familiar place. But that would be a small price to pay.

It was impossible to receive the care she needed in her hometown. Without this ambulance trip, her life would be at risk. She agreed to the trip with some reluctance and told her husband and three-year-old child she hoped to return soon.

Nearly four hours later, she arrived at the clinic where she could receive life-saving care. As the ambulance slowed to a stop outside

the clinic, she felt weakened from the journey and in pain. Her eyes filled with tears. She looked at the faces of the clinic staff to see if she could recognize signs of compassion and understanding. She was from a rural agricultural community, and she hoped that the people here would not look down on her as a person from the country, unsophisticated in the ways of the big city. She hoped she would have the right words to answer their questions, even though she surely didn't have the education they had.

She had come all this way, and now she grew fearful that something might go wrong. She needed these people to save her life.

The staff greeted her kindly and helped her move from the ambulance into the clinic. She walked slowly and gingerly, feeling twinges of pain with every step. As she was helped on to the examination table, she could feel the weight of her pregnancy.

That's when the feeling of relief flooded her limbs.

It was clear to her now that she would get the care she needed and have a chance at living, the opportunity to raise her daughter, time to love her husband and to think again about someday returning to school, finishing her degree, then working in a kindergarten classroom. All this and more seemed to open up before her as she lay on the exam table.

Her cancer had advanced so quickly; she was shocked at how painful it had become. Now, the people gathered around her in this room would perform the safe abortion that would allow her to receive the chemotherapy she desperately needed to have a chance at survival.

Lying there, she recalled her own disbelief after learning that she could not get the care she needed at the state-of-the-art medical center near her home. The reason was seemingly straightforward: she could not get the care she needed, because the hospital refused to provide it. With its beautiful hospital rooms, well-trained physicians, and

every medical capability possible, the hospital could have provided care easily and well, with no ambulance ride, no need for her to be far from the people she loved.

This reality required a gravely ill pregnant woman to take a 200-mile ambulance ride from one U.S. state to another where she could receive the medically necessary and safe abortion; she needed to start therapy against an aggressive cancer.

This story reminds me of the fellow mother of twins I've already mentioned having met on a trip to rural Zambia. You'll recall that this woman delivered her first son quite easily at her local clinic—the very clinic in which the two of us stood together at our first meeting—but that delivering her second son was another story. He was breech and wouldn't shift, and she had to survive a substantial motorcycle journey over uneven terrain to receive the care she needed.

In my role, I am often asked by Americans whether it is best to contribute funds locally to a reproductive healthcare center or to a global organization like ours. For me, that has always been an easy question to answer: people everywhere need support. Do both. We should do both/and, not either/or.

It's the same act of generosity in both cases. It's the same act of giving others the opportunities that we have been given or that we wish we had been given. *There but for the grace of God go I.* Or perhaps, *I am in a position now to prevent others from having to travel that path.*

Women lose their lives trying to deliver a baby, and women also lose their lives when they try to end a pregnancy with an unsafe abortion. Though safe abortion is a relatively simple healthcare intervention using a medical or surgical procedure, gaining access to a safe abortion is anything other than simple for many, if not most, women. Over the period 2015–2019, there were over seventy-three

million induced abortions—both safe and unsafe—occurring each year, representing 61 percent of all unintended pregnancies.[27]

When abortion is criminalized or access to a safe service is difficult, women still seek and obtain abortions to end pregnancies. The typical methods of unsafe abortion are horrible and include drinking toxic liquids, placing foreign objects through the cervix, and receiving surgical abortion procedures in an unclean setting. These methods speak to the desperation women experience when they feel that their pregnancy is dangerous or when they feel that the risks of ending it in such a dangerous way are actually safer for them than not doing so. Women's reasons for choosing an abortion are personal and specific to their circumstance. Women fear revealing a pregnancy. They face a health crisis or financial stress. They feel that they are not able to care for another child, or they feel that their families are complete.

Abortion-related deaths leave over 200,000 children motherless each year.[28] The World Health Organization (WHO) reported that from 2010 to 2014, about 45 percent of all induced abortions across the globe were unsafe. One-third of unsafe abortions are performed under the least safe conditions, where the woman or an untrained person uses a method that can cause excessive loss of blood, infection, uterine rupture, or death. In Africa, where Pathfinder has a major presence, roughly half of all abortions occur by the least safe method.[29]

This reality is especially tragic, because giving women access to contraceptives and valuing their dignity and rights is such an effective

27 Jonathan Bearak et al., "Unintended Pregnancy and Abortion by Income, Region, and the Legal Status of Abortion: Estimates from a Comprehensive Model for 1990–2019," *The Lancet, Global Health* 8, no. 9 (September 2020): E1152–E1161.

28 Lisa B. Haddad and Nawal A. Nour, "Unsafe Abortion: Unnecessary Maternal Mortality," *Reviews in Obstetrics and Gynecology* 2, no. 2 (Spring 2009): 122–126.

29 World Health Organization, "Abortion factsheet," November 25, 2021, https://www.who.int/news-room/fact-sheets/detail/abortion.

way to avoid the very unwanted pregnancies that lead women to seek an abortion. When abortion is decriminalized, safe abortion is the norm.[30]

Globally, over eight hundred women die each day from preventable causes related to childbirth, but the actions required to save their lives are not prioritized.[31] Put otherwise, the causes of maternal death are well understood, and overwhelmingly preventable, but they are not prevented. For so many women around the world—both at home and abroad—the day they give birth is the most dangerous day of their lives. The promise of joyousness can so quickly yield to grief. A baby, an older child, a family, a community—all risk suffering the loss of a loved one, a person on whom so many rely. In a 2019 article for *Global Health: Science and Practice*, Angeli Achrekar, Robert Clay, and I wrote, "Despite having global champions for child survival, HIV/AIDS, malaria, and other health and development issues, maternal mortality ha[s] not risen to become an equal political priority."[32]

American women are more likely to die as a result of pregnancy than women in any other industrialized country. American women who die as a result of pregnancy most often lose their lives due to hem-

30 Willard Cates Jr. et al., "Legalized Abortion: Effect on National Trends of Maternal and Abortion-Related Mortality (1940-1976)," *American Journal of Obstetrics and Gynecology* 132, no. 2 (1978): 221–224.

31 World Health Organization, "Trends in maternal mortality 2000 to 2020: Estimates by WHO, UNICEF, UNFPA, World Bank Group and UNDESA/Population Division," accessed May 7, 2023, https://www.who.int/publications/i/item/9789240068759.

32 Lois Quam, Angeli Achrekar, and Robert Clay, "Saving Mothers, Giving Life: A Systems Approach to Reducing Maternal and Perinatal Deaths in Uganda and Zambia," *Global Health Science and Practice* 7(Suppl 1; March 13, 2019): S1–S5.

orrhage during labor and delivery or from heart and mental health conditions.[33]

The death of women as a result of pregnancy is a uniquely American problem insofar as it tracks alongside the country's long history of racism. The maternal death rate for black American women is 2.5 times higher than for white American women. The Commonwealth Fund reports that, "A Black mother with a college education is at 60 percent greater risk for a maternal death than a white or Hispanic woman with less than a high school education."[34] The risk of maternal death is even higher for women living in Africa, the Middle East, and South Asia.[35]

In sharing these statistics, I'm reminded of an animated, angry discussion that took place on the seventh floor of the U.S. State Department in 2011. That discussion followed a *New York Times* article by Celia W. Duggar profiling the death of a Ugandan teacher.[36] The article rightly noted the significant American investment in the Ugandan healthcare system. Yet, despite American investment in the Ugandan system, a pregnant teacher bled to death from neglect at a major Ugandan hospital. The article spurred discussion about what the Obama administration could do to reduce the number of women who die in labor and delivery in Uganda and Africa more broadly,

33 Commonwealth Fund, "Maternal mortality and maternity care in the United States compared to 10 other developed countries," November 18, 2020, https://www.commonwealthfund.org/publications/issue-briefs/2020/nov/maternal-mortality-maternity-care-us-compared-10-countries.

34 Commonwealth Fund, "Maternal mortality in the United States: A primer," Issue Brief and Report, December 16, 2020, https://www.commonwealthfund.org/publications/issue-brief-report/2020/dec/maternal-mortality-united-states-primer.

35 World Health Organization, "Maternal mortality," February 22, 2023, https://www.who.int/news-room/fact-sheets/detail/maternal-mortality.

36 Celia W. Dugger, "Maternal deaths focus harsh light on Uganda," *The New York Times*, July 30, 2011, https://www.nytimes.com/2011/07/30/world/africa/30uganda.html.

especially given the leadership of Secretary of State Clinton, renowned for her support of women.

I left the meeting with an assignment to think about what we could do to make a more significant difference. I was blessed in this task by a terrific team of colleagues within the U.S. government at the U.S. Agency for International Development (USAID), the Centers for Disease Control and Prevention (CDC), and at the State Department—colleagues with years of experience working on maternal health and related challenges.

I also found visionary leaders outside the U.S. government. I was struck by the insightful leadership of Christy Turlington Burns, founder of Every Mother Counts and a world-class global health advocate and model, who after her own challenging experience giving birth to her first child dedicated herself to saving the lives of other mothers. There was Ken Frazier, the CEO of Merck & Co, Inc., who had recently announced a $500 million company investment to "help create a world where no woman has to die while creating life."[37] And then-Norwegian prime minister and later the North Atlantic Treaty Organization's (NATO) secretary general Jens Stoltenberg had just made reducing maternal death the focus of his Christmas address to the Norwegian people. Several years earlier, at the UN General Assembly in 2008, Stoltenberg told delegates, "The fact that we have not made any significant progress at all in reducing the number of women who die in pregnancy or childbirth is appalling. There can

37 Merck & Co., Inc., "Merck Joins Global Fight to Help Save Women's Lives During Pregnancy and Childbirth," News Release, Merck, September 20, 2011, https://www.merck.com/news/merck-joins-global-fight-to-help-save-womens-lives-during-pregnancy-and-childbirth/.

only be one reason for this awful situation—and that is persistent neglect of women in a world dominated by men."[38]

When the group of us across the U.S. government agencies met, I asked what kind of reduction in maternal death we could achieve in a targeted project during Obama's term in office. The initial reply was that we could achieve an 8 percent reduction with a new effort. I knew I couldn't take a reduction as modest as 8 percent back to my colleagues at the State Department.

So, I decided to use a strategy from my business experience of setting a stretch target as a way of inspiring new methods and collaborations. I asked for a plan to meet a stretch goal of a 50 percent reduction in maternal death, and I asked to have that plan in seventy-two hours' time. My sense was that a solid plan could be developed in seventy-two hours or in seventy-two days to the same effect.

The strategy worked. Tedd Ellerbrock, a CDC obstetrician-gynecologist and trained epidemiologist central to the global fight against AIDS, and Angeli Achrekar, then a CDC staff person focused on public health, arrived in Washington the next week to develop the plan. They had such a sense of urgency that they worked out of their hotel so that they wouldn't lose any time moving around Washington.

Tedd was amazing, intense, and accomplished—and he shared the painful memories he had as a doctor working to save the lives of women in labor in Africa and Asia.

Angeli was poised, clear, and resolute—all traits she has continued to exhibit in her leadership at PEPFAR and UNAIDS. Angeli and I also had an instant connection as mothers of twins, meaning that we like to get things done as quickly as possible.

38 UN News, "Failure to reduce maternal mortality rates shames us all, Norway tells UN," United Nations, accessed May 7, 2023, https://news.un.org/en/story/2008/09/275162.

After three days working out of their hotel, Tedd and Angeli came to my apartment to present the product of their efforts. My son, Steve, a college student then (and a physician now), was with me and listened in on the conversation. Over Chinese takeout, Tedd and Angeli laid out a simple, powerful strategy: a district-level plan to reduce the three delays that cost women their lives, leveraging the assets and health systems infrastructure from years of U.S. investment. These three delays are

- the delay when a woman and her family don't have a plan to seek trained help for their labor and delivery,

- the delay in reaching a site where they can receive good care, and

- the delay in receiving care when they reach that site.

By investing in communication, transportation, health workers, health infrastructure, and equipment, we could address each of these issues in turn.

The plan was simple, straightforward, and achievable. It didn't require a new invention or a conceptual breakthrough. But it did require deep know-how of program implementation and the ability to truly partner with communities and countries. We knew it could be accomplished.

It is hard for me to convey how remarkable our conversation was. The sun had long gone down, but it was as if a light was shining through the room, brighter and clearer even than the sun. There was a stillness—a pregnant pause—the universe waiting to see what would happen next.

When Tedd and Angeli left the apartment that evening, I burst into tears.

My son, Steve, put his arms around me, and I tried to explain my feelings in that moment. Now that we had the plan, we had to do it, and I knew that doing it would be so hard. I felt both joy and fear—joy at the real possibility of making a significant difference and fear of the painful process it would take to shift agency infrastructures in order to do so. It would require engendering hope and confidence that we could save mothers' lives when many in our field believed it was just too difficult an undertaking. It would require people to move out of their existing patterns and agency preferences to work together in new ways toward a common outcome-oriented goal and with urgency.

After that conversation over Chinese food, I knew there could be no turning back.

When I think back on that feeling now, I think of sitting by my younger sister Mary's bedside in October 2022. She had been diagnosed with Stage Four cancer in mid-June and was at the Mayo Clinic nearing the end of her life. It was the middle of the night, and I had been dozing when the kind, skillful nurse tapped my arm to say, "Your sister's situation has changed, and she's coming close now." I wanted to tell her, "I'm not ready for this. Do you think you could come back a little later?" I understood that being present with my sister in her final moments was going to be extremely difficult. But I also understood that I could not turn away. I held her hand as she took her last breaths.

There was something similar in my feeling in that moment talking with my son after Tedd and Angeli had left, a deep bodily experience of refusal—the desire to look away. I felt the full weight of responsibility for doing something difficult, something that was going to put real pressure on me. At once, my tears expressed joy at the realization that I was about to do something that could help save lives

and really *matter* and fear of the experience of having to pull myself into this new role, take those uncomfortable next steps forward, do what needed to be done.

We talk quite a lot in this field about the devastating circumstances all around us—at times, it's almost as if we compete, as organizations, for which of us has the worst set of problems in urgent need of being addressed. We talk, too, about the immense value in taking advantage of opportunities that arise to address the suffering we want to alleviate and to create the positive changes that further empower people across the globe. But what we don't talk all that much about is how the reality of moving toward those opportunities can *feel* like such a difficult thing to do.

Here was a situation in which there was no mystery about how to address the issues. There are three primary delays that cost women their lives in childbirth. And there are straightforward solutions to address each of those delays. Why hadn't a similar plan been developed long before that *New York Times* article drew attention to a single woman's life lost in Uganda?

In the end, our project, called Saving Mothers, Giving Life, succeeded. The effort didn't achieve a reduction of 50 percent, but it did reduce the number of women who died by 44 percent in Zambia and 42 percent in Uganda within the districts covered—reductions in maternal mortality that are seismic. The effort also reduced the number of babies who died during childbirth.[39]

I love thinking about the mothers and children alive today because of this work. I wish I had the chance to meet them. For years after the passage of MinnesotaCare, I would bump into people on the

39 Quam, Achrekar, and Clay, "Saving Mothers, Giving Life: A Systems Approach to Reducing Maternal and Perinatal Deaths in Uganda and Zambia," *Global Health: Science and Practice* 7, no. 1 (March 11, 2019). doi: 10.9745/GHSP-D-19-00037.

street who would tell me how it had changed their lives. That made me tremble inside then and gives me energy yet today.

There are lots of heroes in the story of how we achieved the Saving Mother's outcome. There are heroes I never met who delivered babies all hours of the day, including a delivery of quadruplets in Fort Portal, Uganda. There were heroes among program leaders at the Ministries of Health in Zambia and Uganda, the communities, and the amazing diplomatic and global health staff at the U.S. embassies and across the U.S. government.

Then there were the heroes among the partners who joined us. Naveen Rao of Merck for Mothers and I held our first meeting to explore Merck's role under a tree outside the State Department in the immediate aftermath of an earthquake that shook the District of Columbia. This seemed fitting. Conducting our meeting standing under a tree captured the urgency of this work, and Naveen carried that sense of urgency with him every step of the way.

The country of Norway provided crucial vision and resources. As a country that only ceased being a colony in 1905, Norway brings a remarkable sense of possibility to the global health enterprise, as well as an impatience to see results that are sustainable. Norway punches above its weight and puts the country's fresh resources to good use.

Christy Turlington Burns brought quiet, steady leadership helping me and the whole group keep focused on the mothers and their babies. Her contribution was crucial, because it is all too easy in projects like this one to focus on the politics of the situation rather than the primary objective of saving lives. Claudia Morrissey Conlon, a physician from Iowa with a record of accomplishment in global health, steered this work across the partnership and the U.S. government from her base at USAID with grace, urgency, and persistence.

How did the Saving Mothers team achieve results? Community health workers reached out to pregnant women and their families to raise awareness on the danger signs of pregnancy complications and worked with them on a plan for their care during pregnancy. Importantly, they worked with them on a plan for their labor and delivery so that details weren't left to be negotiated once labor had begun. That plan included telephoning the health facility that the woman was on her way so that the facility would be ready to help her. A transportation system was put in place so that when women went into labor, transport was available without delay. The clinics and hospitals developed just-in-time plans so that trained staff could be at a woman's side for an uncomplicated delivery and so that additional transportation was available should that woman need to move to a hospital capable of performing a C-section and equipped with life-saving services.

Along the way, there were challenges big and small. Women flooded into health facilities for deliveries, overwhelming the capacity of regional hospitals. Women asked for space to be created for them to live near the hospital while they waited for their delivery so that they would not have to be transported at the last minute or risk delivering at home. Blood products needed to be procured and safely stored in areas for mothers bleeding heavily; to meet this need, the blood supply capabilities enabled by the U.S. investment in the prevention and treatment of AIDS also saved the lives of mothers.

The biggest challenge was that we could not save all the women. Mothers continued to lose their lives for utterly preventable reasons. Yet, we demonstrated an enormously important model for a community-wide, multi-partner strategy that addressed all three delays. We established a model that could be, and has been, built on.

When I joined Pathfinder, I was delighted to learn that in the years after I left the State Department, Pathfinder was taking the lessons from Zambia and Uganda to Nigeria in partnership with Merck for Mothers and other donors. Nigeria has one of the world's highest maternal death rates, with about 145 women dying each day.[40] A 2013 study had found that there was a low rate of deliveries at health facilities in Nigeria, because many people regard those facilities as expensive and hard to travel to.[41] The communications between community clinics and regional hospitals were limited, resulting in lack of confidence by women that their needs would be met at the larger facility. Transportation options by roads were often difficult, and there were some areas that were only accessible by ferries. Finally, the facilities to provide basic emergency obstetric care were variable in readiness and quality. Many women and their families elected to deliver at home or in a religious setting because it just seemed more certain and less risky.

In other words, women in Nigeria were dying because of the same three delays we had identified elsewhere.

Nigeria was a natural next place to work. The partners chose Cross River State in the southeast of the country for the project.

40 Uchechukwu Nwafor, "145 Girls, women of reproductive age die daily in Nigeria from pregnancy-related complications — Health indices indicates," Tribune Online, July 28, 2021, https://tribuneonlineng.com/145-girls-women-of-reproductive-age-die-daily-in-nigeria-from-pregnancy-related-complications-%E2%80%95-health-indices-indicates/.

41 World Health Organization, "Trends in maternal mortality 2000 to 2020: Estimates by WHO, UNICEF, UNFPA, World Bank Group and UNDESA/Population Division," accessed May 7, 2023, https://www.who.int/publications/i/item/9789240068759. CF: Sulaimon T. Adedokun and Olalekan A. Uthman, "Women Who Have Not Utilized Health Service for Delivery in Nigeria: Who Are They and Where Do They Live?" BMC Pregnancy and Childbirth, March 13, 2019, https://www.ncbi.nlm.nih.gov/pmc/articles/PMC6416870/.

Saving Mothers, Giving Life also succeeded in Nigeria: the project supported 108 health facilities and was able to reduce the number of women who died at those facilities by 66 percent within just three years.[42] Ward development committees, with our support, raised funds from within their communities so that 90 percent of all the Cross River State communities had motorcycles, cars, and ferries to transport women to give birth in a facility. Importantly, the system was designed to reach women in time and deliver a woman to a facility where she could receive help within two hours. That facility was also enhanced so that it could tackle the common causes of maternal and newborn death. The initiative also offered comprehensive voluntary family planning, including access to short- and long-acting reversible contraceptives.

I visited Cross River State with my colleagues. That visit remains a highlight for me. Two conversations stand out. The first was meeting with the motorcycle drivers responsible for transporting women in labor to the local health facility. They brimmed with pride at the role they were playing! The drivers were reimbursed for their gasoline costs and given a stipend for their service with money raised from the community. There was no dispatch system, so they were assigned to one or more specific women, and when those women called, the motorcycle drivers dropped whatever they were doing and delivered the women for safe care. One driver was delighted to share that on an occasion, he had a paying passenger when the call came. He let off the paying passenger then and there, before they reached their destination, so that he could pick up the mother.

The second conversation was with colleagues, who shared that at the beginning of the program, nearly all the obstetricians and neona-

42 Pathfinder, "A whole-system approach to saving mothers in Cross River State, Nigeria," Pathfinder Technical Brief, July 2019, Pathfinder.org/wp-content/uploads/2019/06/A-Whole-System-Approach-to-Saving-Mothers-in-CRS-Nigeria_Final_July2019.pdf.

tologists in Cross River State worked only in the capital city Calabar, with a focus on providing services at the university teaching hospital. Women and their newborns outside of Calabar received little or no help from these highly trained physicians. Over the course of the three-year project, these physicians began training and supporting medical staff working across the whole state through a rotation and mentorship program with the teaching hospital. I asked them how they had achieved this. They said that the Pathfinder Calabar and Abuja-based teams working on the project facilitated visits and interactions with the communities around the health facilities outside of Calabar and shared the morbidity and mortality data from baseline assessments that depicted what was happening. When confronted with the reality of the situation, the doctors chose not to turn away. They saw that they could clearly affect outcomes in these communities, decided to make sacrifices, bring changes to their practices, and started helping save more women's lives.

Women die because of pregnancy in the United States and around the world for reasons that are well understood and nearly always preventable. While the reasons for a woman's death may vary, the underlying reason is the same for women everywhere—as Stoltenberg put it over a decade ago—*the persistent neglect of women* across the globe. Women are left to navigate on their own the real challenges created simply by their unique reproductive capacity. But the reality is that these challenges have been explicitly designed and left in place by leaders in governments, corporations, and civil society—and women suffer the consequences.

When I asked one of my colleagues why the approach we set in motion in the Saving Mothers project hadn't been tried before, his answer was, "No one ever asked us to do it."

That was the simple step that had not been taken and that, once taken, led to a 44 percent reduction in the number of women dying.

Hearing his answer, I thought back to my request that a comprehensive plan be produced within a seventy-two-hour time frame. I'd invented that limit in the throes of heated conversation. I wasn't beholden to the secretary of state or anyone else to produce a plan in three days' time. But something about the urgency that deadline created shook our discussion out of its focus on hand-wringing over statistics and batting around abstract ideas and directed us, instead, toward getting to work using our resources to save lives as quickly as possible. Without that pressure, the group of us might have found ourselves able to look away from the unbearable reality of all those preventable deaths.

It's a much easier thing to do, look away.

But it's also the case that in our lives, opportunities arise for us to turn toward the roles that allow us to do what really matters, what will make a measurable difference.

In both the United States and everywhere else, those opportunities arise. And in most every case, we can feel the significance, the weight of what we're being invited to do. Those moments cast a strange light and still the air.

Doors open, and it might surprise us where we find them. Some of the greatest opportunities to impact reproductive rights is in the work being done to address climate change, weak health systems, and lack of financial opportunities. So, when we find an open door that leads down a path we weren't expecting, that doesn't mean we won't find what we're looking for.

When faced with a door, it is still entirely up to us to step through it.

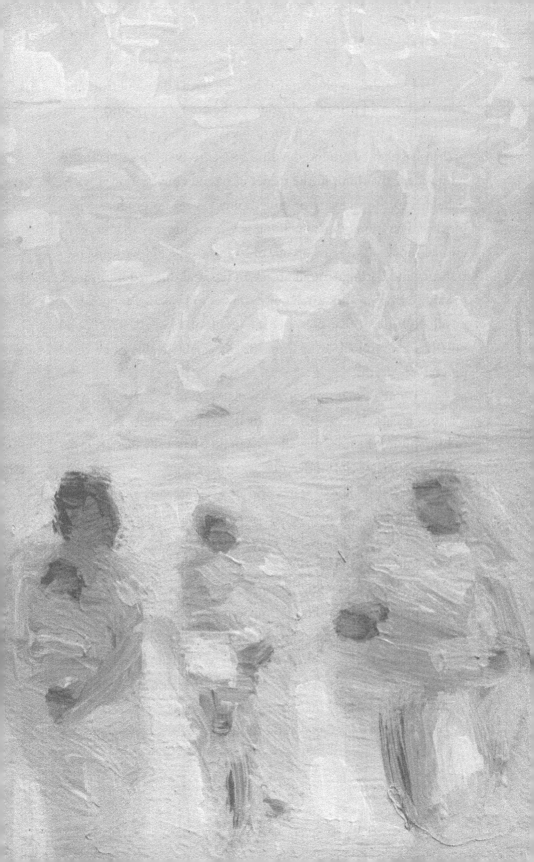

At the Heart of Everything

J oseph Komwihangiro's birth, itself, was a surprise. Twenty-two years after she had her first child, Joseph's mother thought she was beyond her childbearing years. Yet, this surprise arrival of her youngest son gave Tanzania and the world a leader able to see and seize new opportunities.

Joseph, Pathfinder's leader in Tanzania and a Kofi Annan Global Health Leadership Fellow, grew up as the son of coffee and banana farmers. He longed to be a doctor. However, his excellence at school actually made it harder for him to begin his medical training. After obtaining one of only a handful of seats in secondary school—an opportunity denied many qualified students—Joseph secured one of only twenty-four places in Tanzania's brand-new, premier agricultural school where he studied agricultural science, biology, and chemistry. Yet, this very honor meant he could not study physics, a course required for entrance to medical school in Tanzania. What did

he do? He pivoted. He found a medical program in Hungary where he could enroll. He learned Hungary's difficult language and then received his medical degree at the University of Pecs Medical School.

Returning to Tanzania, Joseph practiced at the capital Dar es Salaam's leading hospital and immediately confronted challenges totally different from that he had in Hungarian medical school. Children died constantly from totally preventable illnesses, such as diarrhea and malaria. In a single night, he signed the death certificates for up to six children. On another day, he faced yet another death—this time, a child suffering from anemia. While racing to the blood bank for the supplies that could save this child's life, he tripped and fell. When he returned to the hospital ward, he was covered in blood from his injuries. Colleagues mocked him for trying too hard and encouraged him to get used to seeing his patients die.

Joseph has never gotten used to it. He is tireless in doing more. After that experience, he pivoted again and, with his then fiancé Lilian at his side, drove to local organizations seeking a public health job. He wanted to prevent these children from getting sick in the first place, so he started working at a public health organization focused on child survival. That work led him to recognize that advancing reproductive healthcare and helping women survive pregnancy were the most important tasks he could do.

Today, Joseph's leadership at Pathfinder unlocks women's futures. From his birth in a western Tanzanian village to his work today, his life demonstrates that women's well-being is at the heart of everything.

No family, community, or country can truly prosper if women in their midst don't prosper. No woman can truly prosper without access to the reproductive healthcare she needs and wants. Yet, millions of women around the world do not have this access, dooming their families, communities, and countries to struggle.

Half of all pregnancies globally are unintended, and 275 million women who want to avoid pregnancy are not using a safe contraceptive method.[43] There are many reasons why reproductive healthcare access is not available for millions of women, including legal restrictions, cultural barriers, stigma, inadequate funding, supply shortages, lack of education, poor-quality services, and healthcare provider insensitivity.

Women's access to reproductive healthcare is also hindered by the way these services are often provided in isolation from other healthcare services. This siloed approach can mean that women must make a special trip or use more time than they can spare from their inescapable responsibilities in order to access reproductive care.

Our Burundi leader, Irenee Ndabagiye, shares, "It is really difficult for women, especially those caring for small children, to make costly separate trips for these services. If that is required, it often simply does not happen. During the toughest periods of the year, when malaria is at its peak, we work with the health systems to use mobile clinics to bring services closer."

43 UNFPA, "Seeing the unseen," accessed July 2023, https://www.unfpa.org/sites/default/files/pub-pdf/EN_SWP22%20report_0.pdf.

A siloed approach increases the stigma around these services and renders them vulnerable to funding cuts when new and urgent needs emerge, such as the COVID-19 pandemic.

Reasons for that approach include the well-organized and well-funded attacks on reproductive healthcare, which leave advocates seeking to keep it separate to protect its principles and funding. And some of that isolation is simply the continuation of past work and funding patterns.

Tabinda Sarosh expresses the consequences of that isolation like this:

> One of the reasons that, at times, our work has not achieved its full sustainable impact is the way we have been organized. Reproductive healthcare provided in isolation does not reflect a woman's journey. If a woman is struggling to bring food to the table in her house or has a child who is sick with diarrhea or another common disease, she's going to deprioritize her own health and well-being. If her own health care services aren't connected to fulfilling these other needs, she will miss out on receiving them. Her ability to receive the care she needs is utterly connected to how the health care system works, what the social and natural environment is around her, and whether she has the education and opportunity to earn a living.

Pathfinder has a long history of integrating reproductive health services with the other vital services a woman needs. Dan Pellegrom puts this in perspective. He relays a watershed moment where the organization was considering whether Pathfinder's work should expand to include work on HIV/AIDS. Some colleagues argued that Pathfinder's mission should be kept strictly focused on contraception. But as Dan

tells the story, a Pathfinder from Uganda settled the argument saying, "Well, this is what our clients are facing. And we walk with them."

Today, we know that walking with women encompasses addressing the other challenges they face: climate change, weak health systems, and lack of opportunities for them to earn a living.

As Lydia Saloucou Zoungrana sees the challenges in Africa, "In some places, there is too much water. In other places, there is too little water. We face encroaching deserts and big changes in where the most basic and important crops grow."

We have set the pace for putting women at the center of tangible, on-the-ground work addressing climate change. From our work on Lake Tanganyika's shores to our response to cataclysmic droughts and floods on the Himalayan plains, we have shown that the contribution of women to climate resilience is transformative.

Climate change causes a cascade of negative impacts on women's and girls' health. As Cecilia Sorenson and colleagues write in their 2018 medical journal article: "Woman have distinct health needs, such as nutritional demands during pregnancy, which places them at risk of suffering from climate-sensitive diseases."[44] Interrupted access to contraception can cause more unintended pregnancies and unsafe abortions. Extreme heat and other climate-related factors can reduce fertility, making it harder to conceive a child and build a family.[45] During pregnancy under extreme weather events, women experience

44 Cecilia Sorensen, Virginia Murray, Jay Lemery, and John Balbus, "Climate Change and Women's Health: Impacts and Policy Directions," *PLOS Medicine* 15, no. 7 (2018): e1002603. https://doi.org/10.1371/jounral.pmed.1002603; Eveline J. Roos, "Call for Leadership: Climate Change and the Future Health of Girls," *Journal of Pediatric and Adolescent Gynecology* 35, no. 2 (April 2022): S1083318821003648, https://doi.org/10.1016/j.jpag.2021.12.015.

45 Casey Gregory et al., "The Impact of Climate Change on Fertility," *Environmental Research Letters* 14, no. 5 (2019): 054007. doi: 10.1099/1748-9326/1b0843.

physical stress and have greater difficulty accessing prenatal care and labor and delivery services.

Our Pakistan leader Ayesha Rasheed shares, "For me, coming from a country like Pakistan, which is among the ten most climate vulnerable countries in the world, we see devastation today as a result of climate change. We see devastation in crises like floods, where homes and other essential resources are lost in a moment. And who bears the brunt of this? It's women and children."

Prenatal exposures to the stressors create risks for the next generation's health and abilities. A growing body of research suggests that climate stress on women causes intergenerational threats to brain development, congenital problems, and the risk of longer-term metabolic impacts.[46] Women suffer long-term health problems, such as anemia, as they often eat last in times of scarcity. These disruptions also often increase the prevalence of gender-based violence and child marriage.[47]

In the midst of these challenges, we dig deep and go where the need is greatest. Mozambique Pathfinder Ricardo Cau received one of our highest awards, the Pathfinder Courage Award, in 2021, for making tiring and difficult journeys to reach communities cut off by challenging climate conditions. He traveled by car and foot through grueling conditions to reach cutoff communities in Mozambique's Manica province.

As Tabinda says, it's no wonder that in times of crisis, priorities in a family, a society, and a community change:

Climate change is like an underlying, constant restriction of resources affecting nutritional status, access to education,

46 Heather Randell, Clark Gray, and Kathryn Grace, "Stunted from the Start: Early Life Weather Conditions and Child Undernutrition in Ethiopia," *Social Science and Medicine* 261 (January 9, 2020).

47 International Federation of the Red Cross and Red Crescent, "World disasters report," 2007, https://policytoolbox.iiep.unesco.org/library/RT7NUDV6.

access to health services, and the ability of systems to be responsive and reach people while this is going on.

Women can't face these changes in isolation, even though in many cultures women have been regarded as the custodians of the environment. We have to ask: *What is the role of the systems? How do the systems respond to them?* It is in the DNA of Pathfinder to take a systems strengthening approach. We have for many years increased the envelope size for systems strengthening to include climate change.

Of course, we are not just focused on fostering resilience in the face of climate disasters. We know that women are also *innovators* in the face of climate change. Sorensen and colleagues make the case well: "Yet while the interactions between poverty, gender-based social discrimination, and climate change threaten to amplify gender-based health disparities, women's social roles and potential for agency afford opportunities for promoting solutions to sustainability, disaster risk reduction and solutions to health threats. Ensuring the policies move beyond traditional separations of health gender, and environment and embrace proactive and gender-based solutions is paramount to protecting women's health and mobilizing their vast social potential to mitigate, adapt to and respond to climate threats."[48] We couldn't agree more. Very often, women are responsible for providing food, water, and daily care to their extended families. Fulfilling these responsibilities in a climate-fragile setting requires enormous innovation, adaptability, and entrepreneurship. Communities, governments, and companies can tap into this wisdom and experience to create system-wide solutions.

48 Cecilia Sorensen, Virginia Murray, Jay Lemery, and John Balbus, "Climate Change and Women's Health: Impacts and Policy Directions," PLOS Medicine 15, no. 7 (2018): e1002603. https://doi.org/10.1371jounral.pmed.1002603;

Across the world, many small-plot farmers are women. This means that women farmers know firsthand when crop patterns change because of the weather. In these settings, women can effectively adapt farming techniques to grow new crops or change crop patterns.[49]

In Tharparkar, a rural area in Pakistan and a region heavily exposed to climate-related shocks, women have been adaptive farmers. As our Pakistan team partners with them, we focus first on helping women and girls feel honored and respected so that they can experience their own agency and potential. Our years of experience tell us that for women and girls to feel truly empowered, they must feel that they matter. And we've learned that vital to this work on climate resilience is the provision of services around menstrual hygiene, prenatal care, and access to contraception. During the 2022 floods in Pakistan, which left one-third of the country under water, we worked with the United Nations to provide "dignity kits" to girls and women to meet their menstrual hygiene needs and provide support for women to deliver their babies.[50]

Tabinda shares:

> We also reach out to men and boys, as we do in all our work, to create a supportive environment by emphasizing the ways that the well-being of women and girls benefits the whole family and community. Students, especially university students, see the connections between climate change and repro-

49 SOFA Team and Cheryl Doss, "The Role of Women in Agriculture," The Food and Agriculture Organization of the United Nations, Agricultural Development Economics Division, ESA Working Paper no. 11-02, March 2011, www.fao.org/3/am307e/am307e00.pdf.

50 The UN Refugee Agency, "UNHCR, UNFPA, and UNICEF work together for flood-affected communities," January 30, 2023, https://www.unhcr.org/pk/16073-unhcr-unfpa-and-unicef-work-together-for-flood-affected-communities.html.

ductive health care. Their advocacy then becomes important for the community as a whole. As climate plans, including drought responses, are developed by the government and other organizations for the region, women in Tharparkar sensitize policymakers to the linkages between the climate change response and the needs of women and girls.

Filingue', a rural region of Niger in West Africa, exists on the edge of the Sahel desert. We support farming communities there facing deteriorating harvests as the Sahel expands. Filingue' women's groups consolidate valuable knowledge about what grows where during the changing conditions. These groups have implemented new approaches to strengthen agricultural yields and combat drought. The use of solar-powered systems for irrigation and drought-resistant seeds adapted to the Sahelian climate was literally groundbreaking for that community.

The pressure on farming communities also creates migration from Filingue' to urban areas. Sani Aliou, our leader in Niger, knows that "[t]his creates enormous strain. Farming is the major economic activity in the region. When farming fails, people are hungry. Men will migrate to cities to earn additional income. Increasingly, women migrate as well. Instability for families results."

As Sani shares, "When people migrate from Filingue' to urban areas in Niger, like Niamey, we work with local health clinics and municipalities to support them. It is especially important that migrating women and girls have access to family planning commodities and counseling. We also help them know how to protect themselves against gender-based violence."

Around the great African lakes, Tanganyika and Victoria, our work with communities has also been led by women. Regional planning for sustainable fishing, forest conservation, and improved agricultural ecosystems is at the heart of this work. Importantly, women and girls can decide whether and when to have a child, because they have access to contraception and because this work includes efforts to build support for them among the men in the community. Girls can then complete their education, and women can consider new livelihoods and community leadership roles.

Joseph Komwihangiro shares, "Some of the most exciting features of this work are the improvements in maternity services. So many more women deliver their babies in facilities where trained medical staff help them. Emergency maternity transport by boat and vehicles help women get to higher levels of care when they need it."

Pathfinders in Bangladesh provide further examples of the intersection of reproductive health and climate resilience. Tabinda stresses, "It is our collective duty to ensure that no woman dies in childbirth because she has been cut off from a hospital due to floods and that no child should miss school because they can't swim or must stay home to collect water in a drought."

In several of the communities where we work, flooding because of climate impact has become the norm, and schools have relocated to floating platforms in order to operate during the rainy seasons. But in many parts of Bangladesh, only boys are taught to swim. When schools shifted to floating platforms, girls lost the chance to go to school because they couldn't swim. So, we worked with local communities to offer swimming lessons for girls, which then helped them be able to continue their schooling.

Pathfinder Profile
WOMEN-LED CLIMATE RESILIENCE

In Egypt, through the Women-Led Climate Resilience Project, Pathfinder is integrating education on family planning with work on climate resilience. By emphasizing the strong ties between the two, advocacy on behalf of women's reproductive healthcare leads to more personal and financial independence for women, food and nutritional security for families, and less stress on local ecosystems and resources. Mahi Bebawi, a Pathfinder leader in Egypt, leads the work on green clinics there: "On the one hand, our *Green Clinics* are powered by solar energy, and the clinic staff will be trained on practices like greener waste disposal methods and water conservation measures. On the other hand, we build the service providers' capacity to be able to combat potential health risks from climate change."

Mahi elaborates, "Pathfinder is taking a community-centered approach to climate resilience by working with local families, particularly women, to serve as community *Ambassadors of Change*. We educate women on how to reduce their carbon footprint and their impact on the environment through implementing several women-led community initiatives, including rooftop greenery and tree planting, cleaning the Nile River, and bicycle riding."

The Women-Led Climate Resilience Project integrates women's empowerment and climate resilience efforts through the Egyptian Women Speak Out program. Through this program, Pathfinders empower women socially and economically, giving them the opportunity to gain self-confidence. The program raises awareness among women of their rights and duties, enabling them

to defend themselves against violence and mistreatment. It also helps women develop skills in decision-making and conflict resolution and increases women's ability to participate in public life. One important element of this program is for women to learn how to prepare nutritional meals when climate change alters crop patterns and food availability. Yet another encourages women to generate income by recycling available materials. That includes learning to make handcrafts from banana waste as well as learning core financial and management skills so that they can run any project.

As a key part of the Egyptian Women Speak Out program, women invite their husbands to support them in these micro-enterprises. Without that support, women might suffer at home when they gain their own income, experiencing violence at the hands of their husbands who are jealous or fearful about this new situation.

When supported, these women are able to use their skills and knowledge to adapt and develop inventions that can operate at scale for the community as a whole.

Just as women are at the center of climate resilience, so too are they critical to strengthening health systems. The COVID-19 pandemic demonstrated that healthcare systems are frail everywhere. Even the best financed health systems with state-of-the-art facilities and services struggle.

Broken and weak health systems are dangerous. Across South Asia, the Middle East, and Africa, many health systems are too weak to meet the daily needs of their communities. Women, who suffer most of the consequences of this weakness, are also in the best position to strengthen health systems. Suffice it to say, there can be no health systems strengthening without strengthening services for women.

Women are at the front lines of healthcare provision. In so many families, it is a woman—a mother, grandmother, sister, or aunt—who does the work of triage, who makes the initial, vital healthcare decisions. *Is that just a cough or the sign of something worse? Can we take care of this at home, or do we need to get to a hospital or clinic for help? Is this an emergency, or can it wait?*

Joaquim Fernando, our leader in Mozambique, emphasizes, "To play this role most effectively, women need support. Women with access to education, reproductive healthcare, and healthcare resources are able to provide better care for their families. We see this in the cities of Mozambique and the villages across the whole country."

Women are also the vast majority of community health workers—the first level of staff in healthcare systems across much of the world. Low paid or unpaid women community health workers act as a bridge between their communities and other health services. Trained around a specific healthcare intervention, such as helping pregnant women plan for labor and delivery, community health workers extend the capacity of healthcare systems. Health systems strengthening strategies need to include support for the reproductive health needs of community health workers as a matter of practice.

Lydia shares, "When I started my career, I worked in public health, traveling across Burkina Faso meeting community health workers. I was a young mother traveling with a baby. That fact created opportunities for good conversations about the support that women healthcare workers needed."

Health systems strengthening is especially important to addressing the needs of pregnant women. Safe and effective maternity care relies on systems. There is no drug, no vaccine, or no single treatment that ensures a safe pregnancy. Good maternal outcomes

require a connected healthcare system with good communications and transportation.

As Joseph puts it, "A health system must be strong enough to work in real time or a mother's life is at risk. When a women's time comes, it comes. She can't wait. The care she needs must be there."

Tabinda adds:

We work in a lot of countries where the public health systems aren't completely ready to serve women. The World Health Organizations' six building blocks for stronger health systems provide a framework for our efforts. The building blocks are service delivery, health workforce, health information systems, sound products, vaccines and technology, health financing, and leadership and governance. We look at these building blocks through the lens of women's needs, including sexual and reproductive health care. We ask: how can we strengthen health systems for women, and how can strengthening health systems for women create better care for everyone?

Across Pathfinder's partnerships, public-private collaborations are developed and scaled up to provide more complete services for women. We integrate family planning services into other healthcare services to increase the convenience of accessing them. In Egypt, for example, we work with others to transform Primary Health Centers into Family Development Centers, so a broader range of services needed for healthy families are provided in one place.

We also provide deep technical guidance on reproductive healthcare, so governments, communities, donors, and other key actors can better plan and deliver services for the whole community. Importantly, we work with governments and health systems to develop

costed implementation plans and results-based management systems so that healthcare financing can be put to best use. As governments and health systems set goals for improving reproductive healthcare, we identify laws, regulations, and practices that help them achieve their goals or thwart their progress.

Ethiopia has been a global leader in health systems strengthening. Since Pathfinder founded the first family planning clinic in Ethiopia almost sixty years ago, we have worked with the government and partners to strengthen healthcare services in nearly every part of the country. Ethiopia has invested in local health posts and community health worker cadres, and we have contributed technical input and innovations that put reproductive healthcare at the center.

Joseph notes:

In every place we do this work, we train the health work force—community health workers, community midwives, facility-based midwives, medical officers and medical students to sensitize them to the challenges of women and girls and to train them on tangible skills around providing contraception. For example, we often play a major role in expanding the choice of contraceptive methods so that people can decide what works best for them. Some people prefer a one-time method, such as a condom, and others prefer a long-acting method like an injectable. Some new methods require training and technical assistance as health ministers and their teams develop guidelines, standards, and protocols. Establishing the right guidelines is critical, so we work closely with ministries to do this successfully.

Systems strengthening ensures an adequate supply of materials, whether that be vaccines, drugs, or family planning supplies. Ensuring

adequate access to family planning products, especially logistics management in fragile and crisis contexts, is vital. This is especially important during times of healthcare stress, such as the COVID-19 pandemic.

Our Togo leader Aguima Frank Tankoana shares our experience that "the continuity and use of family planning during a pandemic is feasible when ministries of health collaborate with partners organizations, like ours, to deliver a unified and timely set of messages through multiple channels over and over."

Our Bangladesh leader Mahbub Alam stresses the value of this work:

> In Bangladesh, this is especially important because our country has high goals around access to family planning and improved maternal health and we need to do this in a setting where extreme weather events are common and high impact. In this context, we can work with the government to put in place flexible methods so health systems can respond more rapidly and effectively to changes and shocks.

All of this work ultimately needs to be translated into communications materials for the health workers and women using the systems. Materials need to reflect local languages and preferred communications approaches. Cell phone message systems, social media, radio, television, and print mediums reach different audiences.

"A terrific amount of innovation is necessary to develop ways of communicating health messages that will be truly heard. What might feel right to a health professional does not always attract the attention of the young person needing the services. Vital health messages are ignored or not understood unless considerable time is taken to get it right. We have learned this well and were able to use the skills we developed to integrate family planning in health care systems when the pandemic emerged," says Amina Dorayi, our leader in Nigeria.

Tabinda shares:

This is especially true for sexual and reproductive health information because these topics are so personal and sensitive for patients. For health care workers, communications need to combine the core clinical and technical aspects with messages that help them empathize with their patients. That work around empathy is important because otherwise they may wittingly or unwittingly put their own choices about when, whether, and how many children to have onto their patients.

As we work with governments on health systems strengthening, we reach out to local government and business leaders, cultural leaders, and religious leaders to listen to their input on the importance of stronger health systems and acquaint them with new healthcare guidelines.

In Burundi, we work to strengthen the capacity of local service providers in the public, private, and faith-based sectors to pull together quality malaria treatment and prevention, family planning, maternal care, and children's services. We develop strong postpartum family planning services within maternal and child health programs. We do the same for women living with HIV so that they can receive HIV treatment and family planning services in the same place at the same time.

Supporting all these efforts is deep work to track accountability and performance across health systems, deploying good information technology and trained personnel for management reporting, knowledge transfer, and research. This means collecting comprehensive, quality data that can provide an accurate view of the strengths and weak points in the healthcare system. Matching this analysis with underlying national and regional government budgets and economic statistics is vital to longer-term planning and provision. "Understanding what the gaps are, and then what could be some of the solutions is central to our focused health systems strengthening work," says our leader in Cote d'Ivoire, Ernest Konan Yao.

There is yet another area where integrating reproductive healthcare is vital, and it's this:

There is nothing like having your own income. Wherever you come from, the ability to earn and use your own money changes your life.

Reader, we know this in our own lives. So, we can imagine what this must mean for women everywhere. It's a game changer.

Reproductive healthcare gives women and girls the opportunity to make choices that work for them. These services are foundational to achieving women's livelihoods. We work with local businesses to create opportunities for women and use digital capabilities to make

financial transfers easy and less costly. Importantly, we back up these efforts by working with firms to create safe working conditions free from sexual harassment and other forms of gender-based violence.

Reproductive healthcare and rights are at the heart of a woman's ability to earn her own income over her lifetime, because they allow a girl to finish her education. The ability to make reproductive healthcare choices allows a woman to consider different kinds of work and to return to work after she marries or has a child. Women's ability to achieve a stable financial footing depends on staying in work over time and therefore learning the new skills and abilities necessary for advancement.

Lydia says, "We listen to the communities we work with to understand how they see the problems they face and what the nature and pace of the solutions can be. We never do this alone. It is always working with communities, governments, health systems, religious and community leaders. One of our greatest skills at Pathfinder is listening."

As we listen, we hear the calls of women ready for a better life for themselves, their families, and communities. Especially now, given the challenges of today, there is no time to waste. We need to act now to unlock the immense talent, energy, and inventiveness that women offer.

And we can. We know what to do.

Women are at the heart of everything, and reproductive healthcare is at the heart of women's health and well-being.

Whatever your cause is, this is your cause.

Pathfinder Profile

RICHARD BERKOWITZ
Board Chair, 2014–2019

Sometimes organizations have just the right board chairs at just the right time. Pathfinder, during my tenure, has been blessed with exactly that. Richard Berkowitz was the chair of Pathfinder when I joined as CEO. A visionary, Richard was one of the very first ob-gyns to understand the important role ultrasound could play in pregnancy. His entire professional career in this country has been spent as a member of the faculty of three prominent East Coast academic medical centers where he became internationally recognized for his work as a gifted clinician caring for women with complex pregnancy problems, an educator of several generations of young physicians in training, and an innovator in clinical research studies.

This combination of vision and the courage to do hard things led to Pathfinder's examination of itself, an examination that led directly to our country-led strategy. Richard launched the *One Pathfinder* initiative, which fundamentally changed the organization by engaging Pathfinders across all countries and roles in organization-wide activities to redefine Pathfinder's mission, structure, and activities. This shift was the first step away for a traditional, hierarchical, headquarters-field structure toward organization-wide engagement that included staff from all levels and all countries.

Richard entered medical school after majoring in philosophy and serving in the Peace Corps in Mauritania and Nigeria. To me, that makes him something of a Renaissance man. During his tenure at Pathfinder, and whenever the two of us met up in New York, our

conversations often started with lessons from literature or history that provided a broad, expansive view of Pathfinder's role in the world.

Richard came to Pathfinder after early experiences as a newly minted physician working in East Africa. Caring for women in distress arriving at a mission hospital in rural Kenya after prolonged labor was deeply rewarding and, at the same time, deeply discouraging. This work was a daily reminder that women needed better—much better—access to sexual and reproductive healthcare. When he returned to the United States, he found Pathfinder as a means of fulfilling this calling.

That deep understanding of our mission from his work in Africa, a readiness to act with urgency borne from the experience of high-risk deliveries, and his commitment to lift up the value of all Pathfinders wherever they worked and whatever role they played made Richard a terrific partner for me and a welcome leader as Pathfinder navigated a rapidly changing environment following the 2016 election.

I felt sure that Pathfinder could weather any challenges that might come during the Trump administration if Richard, as board chair, could be available and ready to work with me to make difficult decisions under the pressure of time. When I asked him if he was comfortable with this, he smiled and reminded me that his life's work in high-risk obstetrics was all about making difficult life-and-death decisions under the pressure of time. At first, I felt sheepish for asking such a question, and then, I felt relieved that I had. My next thought was *this is going to be great!*

And it was. There were true crunch moments during that period, especially given the unpredictability of government decision-making. To have Richard on the other end of the phone ready to handle the tough questions then and there was so important for keeping our organization on a steady trajectory. Richard's leadership guided us through the days of the Trump administration and laid the groundwork for the next stage of Pathfinder, fit for purpose in the twenty-first century.

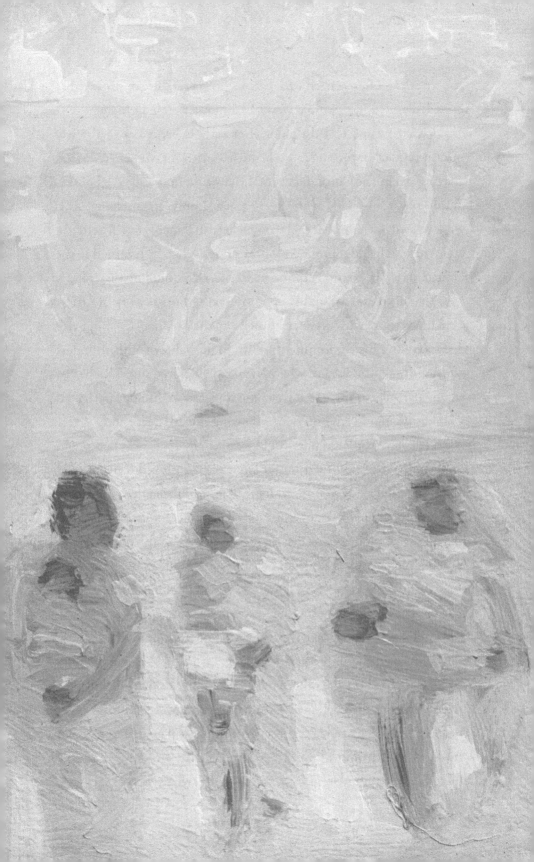

Making Technology Matter

Darlene Irby and I met in a usual way during the pandemic. We interviewed using Zoom. We were recruiting a new leader in digital technology, and Darlene was our top candidate. It was also the case that Darlene was interviewing me to see if Pathfinder would be the right place for her. These details turned out to be the only things that were usual in our extraordinary conversation.

Like many exceptional Pathfinders, Darlene is someone who could work anywhere. She's led traditional information technology teams and guided technology transformations in large, complex organizations, across multiple health sectors, both in the United States and globally. I was especially impressed by her work introducing new medical systems in hospitals, knowing how difficult that kind of change can be.

In our conversation, Darlene was clear about her dedication to placing technology tools in the hands of people across all walks of life so that they can develop life-changing skills, access accurate information, and then use that information to make better decisions. She cares about women and understands that information system transformations are about far more than incorporation and deployment of cutting-edge technology. These transformations are deeply human endeavors in which individuals and communities are challenged to confront age-old mindsets, traditions, and established ways of working.

I was curious to learn what had brought this talented leader to Pathfinder. In that initial Zoom meeting between us, it became clear to me that Darlene wanted to work in an organization that made use of her technology experience to encourage meaningful social change. She expressed a deep affinity for our mission. Like me and so many others, Darlene came to Pathfinder eager to bring transformative change, knowing well all the challenges that bringing such change entails.

What I know from my own experience is that it can sometimes be exhausting to lead change. I have found that the best way to gain energy for this hard work is to sit and talk together. Several months in, and just for this purpose, I asked Darlene if she would come to Minnesota to visit with me in my backyard on a warm summer day.

In that conversation we shared personal stories, and I learned more about how Darlene's commitment to Pathfinder's work is borne out of her life experience. When I started writing this book, I invited Darlene to share some of that story. She agreed and spoke plainly about her past:

> I grew up in the urban south in a housing project. My mother had a grade school education, and by the time she was 28 years old, she had seven children. At age 28, her

doctors pressured her into having a radical hysterectomy. They deemed it undesirable for an undereducated Black woman to have so many children. My siblings and I grew up poor, and I watched my mother struggle mightily to help us get by.

I have four female siblings, but I don't remember anyone ever talking with any of us about sexual and reproductive health—not anyone in the community, and not anyone at school. Teenage pregnancy was widespread where we lived, and my four sisters were all pregnant by the age of 19. I lived in an environment where women were victimized because of their sexuality. Early on, I learned that if I wanted to advance, I needed an education, and I needed *not* to have children.

Even though I'm from the U.S., my experience was similar to the experiences of many of the women I've met in Africa. There's a direct connection between me and women in developing countries.

Darlene has found ways to ensure a measurable impact by connecting digital technology with a deep understanding of the social and community settings into which that technology is placed. It's also Darlene's job to ensure that our digital technology isn't just cutting-edge, but that it is also used primarily to enable equity and support gender-transformative, rights-based, people-centered approaches. The process of digital growth must be locally driven, integrated with existing systems, and it must, more than anything, be sustainable. Digital technologies allow whole organizations and sometimes whole industries to interrogate their assumptions, their plans, and their

approaches in a timely way, on a regular basis, so that they can more efficiently make changes in the ways programs deliver on impact.

If I were to offer an example of one way that technological advance bears on our work, I'd mention those technologies that provide real-time and up-to-date information to individual users across an organization. Business intelligence tools and dashboards can offer powerful insights, and advanced data analytics tools, such as artificial intelligence and machine learning, can combine and synthesize data from multiple sources—programmatic health data, finance data, operational data—whether structured or unstructured, into formats that are both easy to understand and easy to use. We use artificial intelligence in our work today and are expanding its applications on nearly a daily basis. We see the opportunity for artificial intelligence to provide more specific and tailored solutions allowing us to benefit people more quickly.

But I'd also draw attention to the way that the deployment of even quite simple technologies helps address immediate and pressing needs. Earlier, we looked briefly at programs that help address threats to mothers' and babies' health and survival, including the threat posed by delays in transport to a medical facility. As part of providing emergency transport for mothers and babies in Tanzania, the program we developed required a dispatch center. Pathfinders needed to develop a mobile application, set toll-free numbers for users, recruit and train dispatchers and drivers, and set up payment systems so that private taxis can be reimbursed properly for their efforts. That technology helps the dispatcher to conduct remote triaging of cases to determine the type of emergency and treatment needed and to ensure that women and babies are referred to facilities that can provide the required services. And when pregnant women go into labor, the dispatcher can access a network of community drivers on call to get

to the closest health center, especially in cases when ambulances are not available. This effort resulted in 38 percent reduction in maternal deaths in the region over the span of three years and is now being scaled up nationally in all regions of mainland Tanzania and Zanzibar.

Innovations like these are part of a digital transformation that is taking place across the global health sector. We are often said to be living through a Fourth Industrial Revolution, one marked by exponential growth in technological advancements. But this exponential growth is unevenly distributed, reaching some users and missing others, while coupled with ever-growing demand. And sometimes it's the case that the mere introduction of digital technology brings individuals and communities into direct confrontation with the world's oldest and most intractable barriers. Whenever we speak of new technologies, we must also recognize that it's what we do with them, and to whom the privilege of access is offered, that determines their true effects in the world. In the world's lowest-income countries, women and girls are disproportionately impacted by what we refer to as the technology gender divide. The divide also means that women may not even have access to a mobile phone or to the internet—both sources of much-needed online educational content.

Early in Darlene's career, when she traveled to some of the most remote and rural locations in the world, mobile phone access was limited to male members of healthcare teams. Phones were not made available to women, who most often worked in lower-skilled jobs at health facilities and had to negotiate heavy family and childcare responsibilities. It was common practice that women did not have access to mobile phones beyond the workday or that they had limited access to phones that were otherwise kept in locked cabinets. Additionally, phones were shared, and time spent online was controlled by the primary—male—owner of the phone. This meant that the men

could access valuable training on their phones that allowed them to learn new skills and remain competitive in their fields.

Every now and then, a woman would show up to one of Darlene's training sessions, always very quiet and demure. On every occasion, Darlene and the women would be shocked to see one another. Darlene would be shocked to see a woman attending the training, and they would be shocked to see a woman leading the training.

Part of Darlene's responsibility at that time was to travel to rural areas in Rwanda to teach staff at hospitals how to collect data using phones. At one of these training sessions, she noticed the only female trainee struggling to use the phone. Not wanting to draw the group's attention to this woman's struggle, Darlene pulled her aside to offer some one-to-one attention. The woman was nervous and scared; it was her first time using a phone, and this attention from her trainer was intimidating. Darlene went through the process of introducing her to the phone and could see how quickly she understood and took to the new device.

> Over the years, I would meet with her, tutor her, every time
> I went to Rwanda, which was quite frequently, often for six
> weeks at a time. I saw her develop from someone who had
> never used a mobile phone or a computer to a demure data
> clerk, then a data manager, and the last time I saw her, she
> was carrying a briefcase! This woman's experience of having
> her life changed was also life changing for me. I always knew
> that technology was empowering, but I never recognized just
> how much. This woman was able to shift the trajectory of
> her entire family's existence by having income, and then she
> came to be part of the vanguard changing the perception of
> women working in technology.

I approached my work differently after that interaction, because I realized that I could have an impact on other women by reaching out to them in ways that some might not, like taking the time to talk with them about shared experiences and to mentor and develop them.

I started to take more seriously than ever before the importance not just of investing in communities and local solutions, but the amazing effects that could come from investing in specific individuals. Now, I go somewhere, and I inquire about the people with whom I'm partnering: *What does this person need?* and *Can we give it to her?* Person by person is where I've always felt I've made the greatest impact.

Though much progress has been made since then, barriers such as digital literacy, mobile phone and internet infrastructure, and the cost of smartphones and internet access remain key drivers of the technology gender gap. The goal, of course, is to bring together communities and ideas in ways that facilitate a web of connections leading to actual, measurable change. This requires connecting human intelligence with the digital tools enabled by artificial intelligence.

When it comes to facilitating greater uptake of technology and greater understanding of its capacities for intelligent connectedness, Darlene emphasizes both the importance of creating partnerships and networks and the importance of respecting each community's needs. In Darlene's words, "To implement or deploy technology well, Pathfinders have to partner and collaborate. And the first step in that direction is to make no assumptions about what people need and how they might utilize new skills and resources within the context of addressing their own challenges. First, we understand. Then, we wrap

our digital technology approaches around what's already there. That means each engagement is unique."

That sunny afternoon in my backyard and since, Darlene talked with me about her privileged position as a black woman entering the communities in which we work. She's granted access that others are not—invited into homes and included in conversations that offer insights and information about how we can make a real and lasting difference in people's lives.

Darlene gives the example of working in a rural community in East Africa. One of the nurses working in Darlene's clinic was very obviously being abused by her spouse. It was clear to Darlene and her team that they couldn't engage this woman directly on the matter, because that would risk making her life more difficult rather than alleviating some of her suffering.

Instead, they decided to train this nurse to do basic data entry work. At first, the nurse was fearful that if she excelled too far ahead of her husband financially or otherwise, there would be complications—not only from her husband but also from her family and within her village. To help, Darlene's team engaged some of the men in its circle to talk with the spouse and gently make a case in favor of his wife's training. In that way, the nurse was able to gain some skills, and the spouse was able to see at least one benefit—that she could bring home bread and rice.

Darlene and this woman established a close mentoring relationship, and today the woman helps lead a global health organization.

As Darlene sees it, "I've shared with women in Africa my experience growing up in poverty. I've shared my experiences of gender-based violence. I've shared painful experiences living in a male-dominated society and being devalued as a woman. And I've shared my experience of not having full access to healthcare or education or being able

to determine my own agency for most of the time that I was growing up. That connects me to a lot of women I meet, across countries and cultures."

For Darlene, challenges like the one this woman faced present good reason for figuring out as specific and local an approach as possible and for understanding the deep dynamics and issues within a given community, whether at home or abroad.

Here in the U.S., we issue broad policies, but we really don't understand what's going on at the community level and in different locations throughout the country. How, if at all, do the broad policies speak to the local dynamics? To what extent are our attempted interventions having their intended effect? Whether in the U.S. or elsewhere, when you connect with someone who's had similar experiences, who can relate to what you're going through, that's key to establishing the sort of honest and trusting relationship in which some of our best work can occur.

Darlene's insights remind me of one of Pathfinder's greatest achievements: our organization was one of the earliest of its kind empowering countries to lead their own development trajectory. There's still plenty of work to be done in that regard, work that includes establishing partnerships across the globe to address the need for resources, for increased capacity, and for a more robust infrastructure to support digital technology use. The gender divide is still real, everywhere. It's a reality in Africa as well as in America.

And Darlene is the kind of leader who carries forward what is best about our organization:

I think that I'm a great example of how an American story can be transposed into an international story. Pathfinder is the first place I've worked that has wanted to embrace the whole me, the fullness of my interests and the whole of my story. Before working here, I never shared my personal history in a professional setting. I felt ashamed of it and afraid that my background would hold me back in my career. But I'm not afraid anymore. My story is, after all, who I am, and I can see that my experiences are an asset to the work that we do. Who knows where I'd be had I not found what paths I did, had I not had some help following those paths to create a life different from those I saw all around me growing up. Today, I am at Pathfinder because we engage people and communities in determining their own destinies, as I was able to do with mine.

Our destinies are determined by our decisions. And our decisions are mostly our own when we have access to the resources and tools that help us be well-informed and well-educated about our options and their potential consequences. It's imperative to ensure that women have access to helpful information and resources and can develop the skills that give them the power to determine for themselves the trajectories of their own lives.

That's the very heart of who we are.

What Could Be

We've considered the past and the present, and now we look to the future.

Every new generation brings promise. Fresh perspectives can address old, once-thought intractable problems. Generational energy invents new answers to old questions. Young people see the ability to address problems in fresh ways, whereas others have accommodated those problems as if they were inevitable.

Yet, if they are not supported, new generations of energetic, talented young people can be left behind.

We know how to support young people by offering them dignity, recognition, and purpose. We can offer insights and experiences that allow them to learn to navigate their world. We can offer them the opportunity to grow up before they face the responsibilities of adulthood.

In other words, we could invest what it takes to change the world for the better in one generation if we put enough effort and energy

into supporting the hopefulness of the world's young people. Then, we can also learn from them.

We can also widen our view of what is possible. We can recognize the narrowness of our past perceptions and apply our learnings, our tools, and our ways of working to create new opportunities.

We have learned a great deal about offering people the choice and the tools to prevent unintended pregnancies in ways that are both high-quality and dignified. We can now also use those learnings and insights to help people fulfill the dream of having a child and supporting their families when they do.

The future offers us the opportunity to make new choices, to break past cycles, to challenge the contradictions between what we intend to do and what we are doing. Old habits and power structures die hard. But we can create new habits, new structures, new ways of being that are free from historic limitations. Shifting from traditional global health and development models, rooted in historic colonial patterns, to country-led structures is a new path we can walk together.

CHAPTER SEVEN

Change in One Generation

I t had been a busy night at the hospital. A young doctor, Marie-Claude Mbuyi, had gone to rest in a sheltered space just next door to the facility. She'd just fallen asleep when the guard came to wake her. There was another young woman in need of urgent care. As Marie-Claude sat up and pulled herself together, she learned from the guard that the young woman had arrived at the hospital accompanied by her mother and uncle.

The young woman had left school because of a pregnancy. Her parents had taken her to the house of her boyfriend, a tradesman, and forced a marriage between them. During her pregnancy, the mother and uncle had been the young woman's advocates, doing what they could to get her the care she needed.

The family didn't have a lot of resources. When she went into labor, the young woman received assistance from a traditional birth attendant at a community health center near her village, a setting with

little equipment and staff with very limited training. The woman had tried and tried to push the baby out. She tried for hours and then for days. If she could push the baby out, it wouldn't cost the family much, and she wouldn't have to risk the travel to a hospital miles away.

But all her efforts, all her pushing didn't work. The baby was not born, and the family brought her to Marie-Claude's hospital to try and save her life. By then, the situation was an emergency. By the time she came through the hospital doors, her baby was dead.

If she'd had a timely C-section, her otherwise healthy baby would have survived.

The young woman was awake when she and her relatives came in, but she was very tired and weak from nearly three days of trying to give birth. Marie-Claude and her team did a C-section to remove the baby. Then they fought to save the mother's life, to stop an infection from spreading, and to stabilize her breathing. The team worked all night. She survived; yet, she suffered a debilitating fistula injury—involving vaginal, bladder, and rectal damage—caused by the many days of trying to push her baby out.

Marie-Claude Mbuyi is Pathfinder's leader in the Democratic Republic of Congo (DRC). She's a medical doctor and public health professional with experience in reproductive, maternal, newborn, child, and adolescent health. When I asked her in one of our conversations, "Why are you doing *this* work when there are so many other options available to you?" her answer drew on an important motivator: her own experiences working in difficult settings in rural areas of the DRC, settings where she sensed that simple actions and initiatives that were not taking place could be implemented to save thousands of lives.

"I was working as a doctor in rural area clinics when I developed the feeling that I wasn't doing the right thing," she told me. "All the

while I was doing my work, I felt the dread that accompanies expectations of the worst outcomes. And then the dreaded thing would happen; another complicated case would come through the hospital doors—one that could have been handled very effectively if addressed sooner, or at a larger healthcare facility if one had been available."

That night in the hospital with that young woman and her family is when Marie-Claude made the decision to focus on prevention efforts: "I remember having the thought, suddenly so clear to me: I've got to keep this from happening to another woman. I've got to do something different from waiting here to handle these cases once they've gotten to this point."

In her own upbringing, Marie-Claude had been well supported and trusted by her father and mother. She was the third child, after two sons, but her parents instilled in her the same high aspirations they instilled in her brothers. That practice was the product of Marie-Claude's mother's experience as one of nine siblings, six girls and three boys. As Marie-Claude understood it, her maternal grandmother felt shame at having so many girl children whose possibilities in life were sure to be limited, so her grandmother took it upon herself to ensure that her girls received an education and the possibilities for advancement that come along with it.

When Marie-Claude's mother had her own children, she was adamant that her only daughter would not experience herself as anything but the equal of her brothers in terms of upbringing and opportunity. Already when she was in primary school, Marie-Claude identified a desire to become a nurse. But as she got older, she realized that if she were going to become a nurse, her education would end by the time she was about twenty years old. Marie-Claude didn't like the idea of having to stop learning, so she decided she would become a doctor and enjoy more schooling.

After witnessing the situation of the young woman whose baby was dead and who barely lived through her own labor and delivery, Marie-Claude decided to work on normalizing life-saving care at health centers and health clinics closest to people living in rural areas. At the time, family planning was not permitted to take place at community-level health centers; it was only allowed at hospitals. So, Marie-Claude advocated for global family planning standards to be applied in rural areas of the DRC.

As she saw it, the primary obstacle to better care was access—ensuring that people who live hundreds of miles from hospitals could still receive the care they needed. The next obstacle was ensuring privacy to guard against young people's fear of their parents, neighbors, and friends finding out about them seeking and receiving sexual and reproductive health services.

Within the network of services that try to ensure access to sexual and reproductive health resources, organizations like Pathfinder emphasize human rights and demonstrate the ways that fulfilling those rights protects and saves lives and increases the health of whole communities. But organizations sometimes don't focus enough on privacy, the glaring fact that these are deeply personal decisions about intimate matters. Simply stepping into a clinic that provides reproductive health resources may seem to some young people like too much of a risk. That's especially true in places where everyone knows everyone else.

For young people, particularly when it comes to decisions around becoming sexually active, there are a whole host of privacy concerns. Of course, once they're in the clinic, there are still obstacles to be overcome. Tabinda shares, "We have often seen nurses and other healthcare professionals rebuke a young person for seeking contraception or even refuse to help them. We have looked for ways to

change that pattern of behavior by offering training accompanied by traditional and digital solutions, developed through human-centered design methods, that encourage greater empathy and compassion."

As part of our work, we encourage healthcare providers to consider the consequences of refusing to provide contraception to a young person, or lecturing them, or even humiliating them when they provide services. Lydia notes, "Later, nurses told us that they witnessed firsthand the consequences when a young woman returns to deliver her child—and in some cases loses her good health or her life."

I want to share three other stories of youth education and empowerment.

The first is of a Pathfinder project in Egypt involving immense coordination of stakeholders—from across government organizations, including the National Population Council and the National Council for Childhood and Motherhood; the private sector; nongovernmental organizations; religious organizations; and a host of others—to advocate against a proposed change in the law of the land that would lower the age of marriage for young girls from eighteen to nine. Pathfinders not only worked on the development of a national strategy for the prevention of child marriage in Egypt but also both developed implementation programs that were shown to be successful in areas with the highest rates of child marriage and, eventually, scaled those approaches to meet the needs of communities across the country.

In working to disseminate a convincing message against early marriage, we conducted an assessment of root causes. We discovered that economic drivers were the primary cause (in this case, the pressures of poverty drove families to marry off their daughters and thereby relinquish responsibility for them). We also discovered that awareness of the detriments of child marriage (especially the exponential gains associated with allowing young women to finish school)

was a more important factor than the existence of laws criminalizing the act.

From there, we worked with civil society organizations, the private sector, and government to advocate against lowering the age of marriage for girls. Mohamed Abou Nar, our leader in Egypt, talks about the great pride among all the stakeholders who came together to develop and implement the national strategy.

He notes the great value of cross sector collaboration:

> Now is the time for integration. We cannot afford anymore to work through vertical programming in which specific concerns are isolated from one another. As a sexual and reproductive health care organization, we cannot afford to work just on reproductive health, just on family planning, just on child marriage, because in the end, we're serving the families and the communities. Women's economic empowerment, for example, and economic growth within families and communities is what gets young people thinking of planning for their lives, for their own families. There's a difference in effect between simply showing up and telling people, 'Hey, you have to care about your family,' and introducing programming that actually helps them tackle immediate life challenges. In the latter case, they become partners from the very beginning.

In a related work in the DRC, Pathfinders focused on empowering young people, aged fifteen to twenty-four, to tackle harmful social and gender norms that undermine their sexual and reproductive health and rights. One element of that project was to expand services for survivors of sexual and gender-based violence. According to the 2014 Demographic Health Survey, more than half of women

and girls fifteen years of age and older (52 percent) in the DRC have experienced some form of intimate partner violence, with greater susceptibility among people with albinism.[51] To help create more private spaces for youth to address their sexual and reproductive health needs, we set up places for youth at schools, youth centers, and health facilities, where services are made accessible to all. A remarkably successful project, this work is being expanded to other sites across the country.

At these locations, young people can access counseling, various forms of contraceptives, sexually transmitted infection diagnosis and treatment, and gender-based violence prevention and support services. In conjunction with efforts centered around respect for privacy, Marie-Claude and her team pursued an advocacy agenda encouraging the country to authorize the provision of contraception services through the pharmacy sector. To do this, advocates collaborated with the Ministry of Health, the National Council of Pharmacists, and others to argue that where contraception services were provided in pharmacies and drugstores, young people were found to be more comfortable accessing this resource without experiencing stigma.

Within a six-month period, the Ministry of Health authorized pharmacy-based provision of family planning services. The key to this involved the importance of this step to one of the country's named national goals: the reduction of unmet need for family planning, especially among adolescent girls.[52] Marie-Claude explains:

> Whereas families may be reluctant to accept that their adolescent children are engaging in premarital sex, we discussed with the government and our other partners the available

51 Democratic Republic of the Congo Demographic and Health Survey, 2013-2014, dhsprogram.com/pubs/pdf/SR218/SR218e.pdf.

52 DRC Round 6: Snapshot of Indicators (SOIs), www.pmadata.org/sites/default/files/2019-12/PMA2020-DRC-Kinshasa-R6-FP-SOI-EN.pdf.

data on early pregnancy and forced marriage. Especially in rural areas, when an adolescent girl is pregnant, she's very often forced into marriage. As part of the increased provision of services, we also created a space for ongoing community dialogues focused on just these issues.

There's enthusiasm among the youth and an openness to learning that sits right alongside a lively interest in their own potentials and possibilities. We have done pathbreaking work in Ethiopia on positive adolescent transitions to adulthood for girls aged ten to nineteen. Mengistu Asnake shared the following insight about the program's success:

Top of mind for young people is their livelihoods. They're thinking about how to take care of themselves, how to pay for things. In other words, they're not sitting around thinking about their reproductive health. For that reason, what they appreciate most about the program is that it is not a series of efforts aimed at telling them, "This is how you get pregnant, and these are all the horrible things that might happen if you get pregnant too young." Instead, the program attempts to address the greatest possible number of root causes that could explain why contraceptive uptake remains low among young people who have been provided access. By attempting to address other issues in conjunction with reproductive health—including gender inequalities, school dropouts, and child marriages—the program reaches young people at an even earlier age and

more holistically than has been generally attempted in our field. There are all sorts of things that young people need to thrive in addition to knowing where the health clinic is located.

The program invests upstream and with a more panoramic approach toward encouraging youth to live healthier, happier lives. When sexual and reproductive health topics are addressed, they are linked to a wide range of topics, from puberty and menstruation to nutrition, education, safety, gender equity, psychosocial well-being, voice and agency, and economic empowerment. With young people, we've found greater success by focusing on their futures, broadly speaking. We offer them tools to better understand who they are, empower them to be who they want to be, and encourage them to build the future that they want to live.

When it comes to the matter of building their futures, youth participants have been particularly receptive to goal-setting exercises and to the opportunity to interact with their peers outside of school. Both give them the sense that their interests and aspirations for themselves are being taken seriously. And one of the program's most innovative efforts includes engagement with young men not just as future partners of the young women but also to address their own issues, interests, and needs. Sessions with the youth themselves are mentor-led, and separate sessions offered for parents and caregivers are designed to mirror for them the topics that their young people are learning and talking about.

The more youth connect to one another globally through technology, the more they've developed a shared generational identity. Today's youth are keenly aware that they're part of a wider world;

they are eager to locate the similarities between their own lives and the lives of people tens of thousands of miles away. From witnessing others' lives, they develop new ideas about their own potential and new ambitions.

When I experience young people's energy and review the transformations that have already taken place in the countries where we work, I am reminded that it is possible to change the habits of a society within a generation. One generation! I say that I am *reminded*, because in my own lifetime, and I'd venture to say, in most of our lifetimes, we've experienced moments of generational change and have our own stories to tell of how circumstances themselves shifted in ways that transformed our attitudes and values.

A longtime member of the Pathfinder Board of Directors, Judy Tabb, reminded me that when she started her career, she'd never been taught how to open a bank account or write a check. At the time, it wasn't possible for women to have credit cards, and even after she graduated from law school and was hired by a law firm, she couldn't obtain a loan or mortgage from a client of the law firm without her father co-signing or the firm's partner vouching for her.

Things can change in one generation. We know that in our own lives.

We can sometimes feel that we are out of time when it comes to finding solutions for our biggest problems. That gnawing sense of doubt makes it even more important to remember that it is not merely aspirational to say that significant societal change can occur within a lifetime. It has and can be done.

Our work in Ethiopia offers us a model for encouraging generational change. In Mengistu's words:

> What stands out to me the most is the engagement of
> young men about their own concerns. Offering life skills

and gender equality programming to young girls while only lightly engaging the boys is not the answer. Without question, it's a good thing to talk with boys about the importance of treating their female peers with respect. But when the boys get their own programming that addresses their own needs while having a very large emphasis on messages around gender equality, and when the boys clubs and the girls clubs are brought together for joint gender sessions that are specifically designed to make them reflect on gender norms and gender equality, that's when significant changes can occur.

We have a lot of boys who say at the end of the program that they started helping their sisters or their mothers with things that, traditionally, men don't do. That is the fastest way to change something for the next generation. Now, they're not only being allies for their sisters and cousins and girl students, but they're likely to be better partners later on in life. We can't just keep empowering girls and telling them about their rights and giving them all this knowledge when the boy sitting next to them still thinks the same way that his parents did. That's not going to change anything. Real change will come much faster if we include all kids and not just girls.

That said, one of the undeniable effects of the program was the speed with which specific participants would undergo major life changes. Within a ten-month period, hundreds of child marriages were canceled, directly changing the trajectories of the lives of those girls.

When young people have access to relevant information, they gain the ability to make informed decisions about their bodies and their futures. This empowers them to initiate changes in their own lives that can help redefine who they are and set higher expectations for themselves as they mature. Seyi Bolaji, a journalist and Pathfinder youth advocate, emphasizes the need to address information gaps between generations. A key feature of a holistic approach involves efforts that extend beyond the group for whom an intervention is specifically targeted:

> At the same time that we focus on imparting accurate and comprehensive information to young people, we also provide valuable insights to policy makers and other influential stakeholders who have the authority to make life-changing decisions on behalf of the youth. The older generations mostly misconstrue our intentions, perceiving our advocacy as merely promoting sexual activity among young people. As a consequence, it takes them longer to grasp the true essence of our goals and objectives. But the young people—they get it. They're curious, inquisitive. They already have some awareness, and have a strong desire to know more.

Empowering young girls between the ages of ten and fourteen—especially by helping them identify their voices and their own agency and better understand their communities in preparation for adulthood—gives them greater knowledge of themselves, their bodies, and their environments. It also gives them greater confidence expressing themselves, a more entrepreneurial spirit, and, ultimately, changed attitudes that eventually change the material conditions surrounding teenage pregnancy. The ability to make choices around reproductive healthcare, and to avoid the catastrophe of becoming pregnant before

one's body has developed fully or completed schooling, goes hand in hand with having an expanded sense of one's own possibilities and an ability to set and achieve one's goals. This work can change the lives of *millions* of young people and make it possible to put more of their remarkable talent and energy toward solving the world's problems.

To make this change in one generation, we need to do some things differently. We need to ensure that this work has access to necessary resources, given how strongly we need to engage young people in the collective challenges we face. We need to scale up the many tested and proven ideas, like those reviewed here, for the whole of this next generation. Young people need to be able to generate their own ideas for this work and then collaborate with seasoned entrepreneurs and leaders to test, pilot, and scale their concepts. Giving the world's youth the opportunity to live to their full potential *can* change the world.

In *one* generation.

From Family Planning to Family Building

O f all the dreams I have had for my life, one thing was always clear. I wanted to have children. It burned like a fever inside me from age twenty on. It was my very good fortune that I was able to have three children. Three in twenty-three months! I would have given up everything else for this, and I am still amazed at my good fortune.

So many friends and colleagues have borne the sadness of wanting a child and not being able to have one. So many have endured the hormonal ups and downs and invasiveness of infertility treatments that haven't worked or waited to learn whether adoption might be possible so that they could build families of their own.

Likewise, I have friends and colleagues who chose to have a child and create a family without a partner. They have embraced the decision to raise a child through assisted reproduction and to work

with their parents, other family members, and friends to raise their children.

We know that having a child and creating a family is for many one of life's great joys and challenges. And it can be a complicated process. We've talked about the challenges to maternal and infant health and survival, but we should add to those the complicated processes governing infertility treatment, assisted reproductive technologies, adoption, and surrogacy. Then add to those the business of assembling the "village" that it takes to raise a child.

I'm reminded of two of my colleagues' comments about building a family. Jodi DiProfio, a leader in our Pathfinder U.S. office, summed up her experience as follows: "I used the best technology available to prevent pregnancy until I used the best technology available to enable pregnancy." She was pointing out to me her privileged access to both forms of care, noting that access is not an option for most women globally.

Although the 1994 Programme of Action of the International Conference on Population and Development acknowledged enabling pregnancy as part of comprehensive and integrated sexual and reproductive health rights, little has been done. More recently, the Guttmacher-Lancet Commission on Sexual and Reproductive Health and Rights, established in 2016, emphasized the importance of meeting infertility needs globally. The Commission's report noted that "an absence of political concern combined with the high cost of assisted reproductive technologies have resulted in a huge divide between high-income and low-income nations in the availability of fertility care. Much more could be done, however, to raise awareness about

and prevent infertility, to research low-cost solutions, and to make access to new technologies more equitable across the globe."[53]

Another of my colleagues, who has done award-winning work in family planning, shared her story of facing the challenges of poorly organized, expensive, and poor-quality infertility care in her home country.

Sophia was thirty-six when she sought out fertility treatment. She began by taking medication for ovulation induction. When that wasn't helping, she decided to try in vitro fertilization (IVF) abroad. The success rate of fertility treatment in her country was, and remains, low, and what little infrastructure exists is weak. For these reasons, among others, many women travel to seek IVF services abroad. Sophia held a full-time job, but she managed to arrange three weeks off for her first trip to an IVF center.

Though she received recommendations from colleagues, friends, and family at home, Sophia found it difficult to choose from among the many options available to her abroad. In the country she planned to visit for the procedure, IVF treatment had already become a competitive industry in which practitioners vied for the attention of people wanting these services. There are a lot of advertisements targeting women in Sophia's position, and there is a lot of confusion about the various foreign options and their quality. Though Sophia was able to turn to her doctor friends for their helpful recommendations, she still had to do significant research on her own. Her medical background helped her make sense of options, but after much research and study, choosing a provider and planning the trip still required a considerable leap of faith.

53 Used with permission of The Lancet Publishing Group, from "Accelerate Progress—Sexual and Reproductive Health and Rights for All: Report of the Guttmacher-Lancet Commission," *The Lancet Commissions* 391, no. 10140 (June 30, 2018): P2642-2692, permission conveyed through Copyright Clearance Center, Inc.

Thankfully, Sophia chose well, and the specialists abroad were both very kind and client centered. Instead of making assumptions about how much time she had available to dedicate to treatment, the doctors inquired about how many weeks she would be able to give. That was reassuring to Sophia, who had friends who had stayed in health centers abroad for six to twelve months. Knowing how much time she had to give enabled her doctor to determine how best to help her while she was visiting there and what could be done once she returned to her doctor back at home.

On her first visit, Sophia stayed for three weeks; on her second and third visits, for one month. She experienced several failed transplant attempts.

Then the COVID-19 pandemic hit, and travel between countries was prohibited. She had two remaining embryos, and she was worried about timing. Her clock was ticking, her hormones were low, and her team had already transferred three of the five embryos that had been harvested.

After a year went by, Sophia decided to see what arrangements could be made in her home country. Again, a gynecologist friend intervened, this time with a referral to a famous doctor in the area. Almost immediately, she noticed the differences in service: whereas her doctor abroad had taken care to inquire into her well-being, she regularly waited over two hours to spend between forty-five seconds and two minutes with this one.

At her first appointment, when she told this doctor her story, he surprised her by suggesting she try methods she had already bypassed in favor of IVF: ovarian induction, intrauterine insemination (IUI), laparoscopy, and others.

Before this meeting, no doctor had recommended that she pursue any treatment besides IVF. Given her memory of the strain of that

treatment on her body, mind, and pocketbook, she felt some relief at the thought that she might not need to go through that process again just yet.

When she expressed her confusion and asked why she should choose to pursue those options at this point in her journey, the famous doctor simply said that he preferred to proceed in order: a laparoscopy, then IUI, and only then, IVF.

She agreed to follow his recommendation.

After the laparoscopy showed that one of her tubes was blocked and the other one twisted, the doctor recommended that they try IUI on the side where her ovary was open.

When she asked, "Why did you not try to open the blocked tube?" the doctor answered that it was in a position unlikely to result in success.

Sophia then engaged in four cycles of ovulation induction and twice did IUI. After IUI failed to work, she was already feeling irritable and suffering hot flashes; her hair was thinning, and she worried that her ovarian reserve might have gone down.

At Sophia's insistence, the doctor checked her hormone levels to discover that indeed, they were going down. Only when she advocated for herself by saying, "I can no longer waste my eggs. You need to preserve the eggs," did he agree to IVF.

"But we cannot do it now," he added.

She was stunned.

"Why not?"

"Because of COVID, our embryologist is not able to travel here from his home country for another four months' time."

"You never told me that to do IVF here, you needed an embryologist from another country."

Sophia was hurt, angry, and upset with the doctor, because it suddenly seemed to her that he had been wasting time and money. He had withheld valuable information that would have influenced her choice of doctor. Sophia was also upset with herself. "Why didn't I ask him?" she wondered. "Why had I just blindly trusted whatever he said and not even double-checked with other people?"

After another four months, Sophia was able to return to the foreign center where she had her initial IVF treatments. With only two embryos left, this time, she succeeded in getting pregnant and nine months later gave birth to a healthy baby.

Though after three years of trying, Sophia was able to conceive, she has since shared her experience with others and learned from them that what happened to her was in no way unusual.

> I have come to know many people who have undergone treatments over the course of years without ever having their real possibilities, or their progress, explained to them. I kept hearing the same story: though their age, egg reserves, and other factors suggested that they should go right to IVF, they were encouraged to be on medication, try induction, and so on. This deeply unethical practice keeps happening, with doctors seeking profits over helping their patients.

There are several factors at play in countries like Sophia's. In many of those countries, the focus has always been on pregnancy prevention, not fertility enhancement. In Sophia's country, the government has only recognized a need to focus on treating infertility in the past

five years. However, recognition of that need has in no way made it a priority.

Without government support, fertility services—which require resources like high-definition labs and specially trained practitioners—exist without needed infrastructure support. For a practice area that requires careful coordination among a team of specialists, from gynecologists to counselors, the overall quality of care available in these private practices is highly uneven.

Additionally, the doctor-to-patient ratio is inadequate. There may be one or two or no embryologist residents in the entire country—all others have visiting status. And because there are so few trained specialists, there are no doctors working principally on infertility. Those who might be interested in developing their capacity are left to their own devices. For example, a friend of Sophia's who is a gynecologist is undergoing training to acquire the necessary skills in fertility enhancement. That study requires her to study in two other countries, and she's financing that training entirely herself, unsponsored by any medical or governmental organization.

Finally, in countries like Sophia's, and even when it comes to building capacity by creating centers that are privately owned, there are not enough local or foreign investors to make that a reality. Instead, IVF centers in neighboring countries have outpost offices in hers.

Despite the benefits they could offer, services to address infertility in many parts of the world are poorly organized and insufficiently regulated to protect the safety of all concerned. And in many cases, they are just unavailable. Organizations like Pathfinder can develop high-quality, state-of-the-art, regulatory, and technical frameworks to improve access—exactly as we have done in our work helping to prevent unintended pregnancy. Yet, no donors meaningfully invest in family building.

Surely, we can do better when it comes to addressing the need for fertility care.

As Sophia's story makes clear, the overriding focus of reproductive healthcare has been on *preventing* unintended pregnancies by offering access to modern contraceptive tools and support. We have begun advocating for widening that view to include the modern tools, services, and supports that *enable* pregnancy when it is wanted. We are pursuing programs in India and elsewhere that engage communities to raise awareness, disseminate knowledge to promote fertility health, dispel myths and misconceptions, and advocate for lifestyle enhancements for young people to attain reproductive well-being.

Reproductive care should really be about ensuring that people can make for themselves the most private, personal decisions about their lives, whether that is to prevent pregnancies or invite them. The right to decide whether, when, with whom, and *how* to have children is central to women achieving their humanity. We now have the modern means to help women achieve pregnancy when they want to. Just as it is deeply harmful to individuals and communities to have a child you can't care for because your society has forced you to do so, so too is it harmful not to be able to have a child you deeply want because your society hasn't created the supports necessary to help you do so.

Our work in family planning aimed at preventing unplanned pregnancy is vital and far from done. Yet, it is ultimately too narrow. Exact data is lacking, but analyses estimate that 48 million couples and 186 million individuals face the consequences of involuntary infertil-

ity and that most reside in low- and middle-income countries.[54],[55] Still, availability, access, and quality of activities to address involuntary infertility remain a challenge in most countries.[56] That's true, even though infertility has significant negative social impacts on the lives of infertile couples and particularly on women, who frequently experience violence, divorce, social stigma, emotional stress, depression, anxiety, and low self-esteem as a result.[57],[58],[59] Pathfinder leader in Burkina Faso, Ginette Hounkanrin, and colleagues, for example, have argued that addressing childbearing difficulties is an overlooked, even forgotten, component of family planning programs in West Africa. Insofar as fertility is closely associated with social recognition and social status in Africa, it can impact women's socio-economic and psychological well-being. Ginette and her colleagues emphasize that

54 Maya N. Mascarenhas et al., "National, Regional and Global Trends in Infertility Prevalence Since 1990: A Systemic Analysis of 277 Health Surveys," *PLOS Medicine* 9, no. 12 (2012): e1001356.

55 Shea O. Rutstein and Iqbal H. Shah, "Infecundity, infertility, and childlessness in developing countries," DHS Comparative Reports No. 9. Calverton, MD: ORC Macro and the World Health Organization.

56 Obehi A. Asemota and Peter Klatsky, "Access to Infertility Care in the Developing World: The Family Promotion Gap," *Seminars in Reproductive Medicine* 33, no. 1 (2015): 17–22.

57 Carmen Stellar, Claudia Garcia-Moreno, Marleen Temmerman, Sheryl van der Poel S, "A Systematic Review and Narrative Report of the Relationship between Infertility, Subfertility and Intimate Partner Violence," *International Journal of Gynecology and Obstetrics* 133, no. 1 (2016): 3–8.

58 Brittany Rouchou, "Consequences of Infertility in Developing Countries," *Perspectives in Public Health* 133, no. 3 (2013): 174–179.

59 Marcia C. Inhorn and Pasquale Patrizio, "Infertility Around the Globe: New Thinking on Gender, Reproductive Technologies and Global Movements in the 21st Century," *Human Reproduction Update* 21, no. 4 (2015): 411–426.

services addressing and preventing infertility are a matter of women's rights and equity human rights and social justice.[60]

There is also a close relationship between the decision to use contraception and a fear about infertility. One of the main questions that women have when considering using a long-acting contraceptive, such as an injectable method or an intrauterine device (IUD), is whether they will still be able to have a child later should they choose to do so. Addressing the prevention of pregnancy and the enabling of pregnancy together would be a positive way to address this important consideration. Moreover, when women do face the inability to conceive after they have had one or more children, the cause may well be related to poor sexual and reproductive healthcare. Untreated infections, unsafe abortion, or a difficult labor and delivery are causes of infertility in women who have been able to conceive and bear a child in the past.[61]

Establishing a more equitable approach also necessitates thinking about family building as accessible *to all*. Assisted reproductive technologies enable women to build a family and bear a child in the absence of a partner. These technologies are essential for LGBT persons to build their families. Likewise, the development of sound practices for adoption and surrogacy is important to facilitate family building and to avoid abusive practices. Protecting the rights of birth and surrogate mothers alongside the rights of adopting and intended parents is a vital area of family building that is not yet fully developed. Urgent work is needed here to avoid harmful power dynamics reas-

60 Ginette Hounkanrin, Rosalie A. Diop, Douaguibé Baguilane, and d Ermel A.K. Johnson, "Childbearing Difficulties: A Forgotten Component of Family Planning Programs in West Africa," *African Journal of Reproductive Health* 26, no. 10 (2022): 15–20. https://doi.org/10.29063/ajrh2022/v26i10.2.

61 World Health Organization, "Infertility," April 2, 2023, https://www.who.int/news-room/fact-sheets/detail/infertility.

serting themselves, including discrimination, social stigma, and poor-quality service providers.

Finally, turning our attention to everything at stake in family *building* also involves ensuring community support for parents to care for their children and themselves while earning the wages required to meet their family's needs. Rather than these simply being private challenges, enabling healthy families is a matter for the whole of society.

Combining childbearing and child raising with educational and career advancement introduces its own unique set of challenges for women. While men do not experience a loss in pay by having a child, for most women, across societies, as economist Richard Reeves stated, having a child is monumental.[62] As a result, and if they can afford to do so, many women leave the labor market, especially if they find their work unfulfilling.[63] Others struggle with the costs and uneven quality of childcare to try and do both.

To have a healthy society that fully benefits from women's creativity, expertise, and innovation, we must find better ways to combine child raising and work. This task becomes more urgent as women globally seek greater educational attainment and have ever more to offer in creating solutions to our most pressing challenges.

Norway provides one model for effectively combining child raising and work. My ancestral home is now well known for its oil wealth. However, the power of the modern Norwegian economy rests more on the participation of Norwegian women than on oil. In fact, if Norwegian women dropped their labor market participation to the

62 Ezra Klein, interview with Richard Reeves. *New York Times*, The Ezra Klein Show. Podcast Audio, March 10, 2023, https://www.nytimes.com/2023/03/10/podcasts/ezra-klein-podcast-transcript-richard-reeves.html.

63 Sylvia Ann Hewlett and Carolyn Buck Luce, "Off-ramps and on-ramps: Keeping talented women on the road to success," Harvard Business Review, March 2005, https://hbr.org/2005/03/off-ramps-and-on-ramps-keeping-talented-women-on-the-road-to-success.

Organization for Economic Cooperation and Development (OECD) average, that would wipe out the benefits of oil on the Norwegian economy.[64]

How did Norway achieve these results? A series of economic reforms initiated by Norway's first woman prime minister Gro Harlem Brundtland established broader maternity and parental leave benefits for women during and after pregnancy and while breastfeeding. These benefits were not established as social welfare benefits but as proactive investments in the Norwegian economy and society. Moreover, for women to receive full maternal leave benefits, Norwegian fathers were required to take their portion of parental leave time. That resulted in an increase in Norwegian fathers' involvement in parenting—a further step that benefits families—and women.

I have been struck over and again that Brundtland's vision was firmly grounded in a commitment to *enhancing* women's capacity and potential. She naturally understood the power of women's abilities and aspirations and saw them as a force for good in society. While many focus on parental leave as a benefit for individuals, she rejected the view that these benefits helped only the individual. Instead, she understood them as investments that benefited the whole society—a truly empowering vision.

Other countries can follow the Norwegian model for supporting women as full participants in economic and social life while they bear and raise children. To do this, advocates for women can shift away from the practice of framing women largely as marginalized people and victims. I'll never forget being at a World Health Organization's (WHO) conference that placed women's health within the

64 Katrin Bennhold, "Working women are the key to Norway's prosperity," *The New York Times*, June 28, 2022, https://www.nytimes.com/2011/06/29/world/europe/29iht-letter29.html.

larger framework of the health needs of marginalized communities. I reminded the conference participants that, in fact, women had given birth to every person attending the event. That, in fact, is real power.

Switching away from categorizing women as victims involves acknowledging the capacity and power that some women hold today and that all women have the potential to hold when supported. That means acknowledging the power and capacity of women whose lives are currently consumed by the daily search for food, water, and health-care for themselves and their families. After all, the inventiveness and insights women demonstrate simply by living their daily lives have broader relevance.

As I've argued here, moving toward the practice of acknowledging women's capacity and power also involves finding ways of allowing people to have and care for the children they so deeply want. Pathfinder country teams often talk about our work as addressing family welfare and family well-being or having a happy family, because our work is focused on the positive enhancements to family life: raising healthy, well-cared-for, and educated children in a setting where parents also thrive. Working hard at pregnancy prevention is important, of course, because millions of women suffer from unintended pregnancies. The work to ensure access to these services is far from done. Yet, if our vision is really focused on empowerment and rights, shouldn't it be more holistic, broadened to include growing families?

It's time to move from family planning to family building.

Pathfinder Profile

ROSLYN WATSON
Board Chair, 2019–2021

The period from May 2019 to November 2021 was remarkable for all of us in every organization: a global pandemic that upended our operations, the brutality of George Floyd's murder and the way it made every organization face the racism within, and the gravity of the 2020 American presidential election followed by the January 6 events. At the same time, the environment in which Pathfinder worked and earned the support of communities, partners, and donors changed rapidly driven by new aspirations, technology, and clear dangers caused by climate change and violence.

Governance mattered during this period more than ever. Organizations needed good governance to steady themselves and to respond to the acute unsteadiness of the moment. The needs for steadiness and responsiveness were sometimes in tension with each other. Roslyn Watson, our board chair during that period, mixed steady calm with the ability to understand change and respond within a moment's notice.

Ros brought to Pathfinder her already extensive service on boards and her work as an executive in complex politically charged environments. After growing up in Philadelphia, she had spent her work life in Boston, New York, Paris, and Jackson Hole. Ros is not guided by fear; she confronts adversity with humor, tenacity, and clarity. In the tough moments, she grows stronger, clearer. So as these events reverberated through and around us, Ros was able to offer timely responses to dramatic changes as they were unfolding in real time.

The speed by which Ros was able to digest new realities and consider their implications was always evident to me in our bi-weekly

calls. I came to those calls well prepared with an analysis of the situation and carefully considered plans. Yet, Ros always asked questions that I wasn't prepared for, questions that widened perspectives and possibilities. No matter how much I planned, she always offered a fresh, new thought that put me on a better path. This was exactly what I needed to keep perspective and lead in situations that were truly unprecedented.

As Pathfinder's chair, Ros had a way of helping me grasp and hold my courage. Even at the most difficult moments, there is no room for lamentation or despair when you work with Ros. She called on courage simply by closing so many of our calls with one word: "onward."

We go onward in the face of challenges.

I remember this as especially poignant when we had key leaders gravely ill with COVID-19.

Onward. I'd take a deep breath, grab a cup of strong coffee, and onward I would go.

When Ros assumed her post as chair of our board in May 2019, she planned to focus her tenure on strengthening an orderly process of board governance. Given her decades of executive leadership experience in Boston's Port Authority and board service for several national financial services organizations, this was a natural endeavor for her tenure. It was also an important one for Pathfinder along its journey from the early days as a family-founded organization to establishing itself as the modern, complex organization it is today.

One of Ros' key objectives in this work was to increase board diversity by bringing in members with backgrounds in the countries where Pathfinder had a presence and with experience navigating the kinds of opportunities and risks we faced. I often say that we only

do difficult work in difficult places, so board governance around risk identification, mitigation, and management is vital.

Upon a recommendation from Ros and the two people she credits as critical to the board's success in this endeavor—Board Vice Chair Tim Brown and Governance Committee Chair Jessie Jenkins—a key decision was made by the Board Executive Committee to use an executive search firm to recruit new board members rather than have existing board members recruit their successors.

After an RFP process, Pathfinder hired top executive search firm Egon Zehnder to recruit new board members. This move proved to be highly successful, bringing in diverse talent to the board that far exceeded the board's past practices. Ros also launched the vital, yet unglamorous, work of integrating best board practices. She coupled recruitment efforts with a review and update of the Pathfinder board's governance practices, including committee structure and bylaws and, importantly, board training around the code of conduct and the duties of board members. We had excellent outside help from a nonprofit board consulting group and a skilled consultant.

In the midst of this process, we reckoned with the racist legacy of Clarence Gamble, Pathfinder's founder. Like many other organizations, the knowledge of Gamble's well-documented eugenics views and associated work had been well known to the board for decades but hadn't explicitly been addressed. Ros' leadership was paramount in the decision to examine Gamble's legacy in 2020—work vital to our values and mission.

If all of this sounds easy and straightforward, know that it was not. There were sharply different opinions about these board changes and the Gamble legacy work, which created some real turbulence, culminating with the founding family members leaving the board.

Today, looking back, that turbulence is regrettable, but we have a stronger, more diverse board prepared to guide Pathfinder.

In addition to the turbulence internal to Pathfinder, there was the turbulence felt by all. Every morning felt different. When I awoke each day, I looked at my phone to see what had happened to our Pathfinders: who was sick, who was quarantining, who was facing a political crisis or a natural disaster. What was the status of painful Pathfinder conversations in the wake of George Floyd's murder? What new concerns had arisen in the nervous time between the 2020 election and Joe Biden's inauguration?

Though her tenure occurred during a pivotal period in Pathfinder's history, Ros developed a special relationship with American Pathfinders, providing them with a sense of hope and history, in part borne out of her experience as a Black woman in America. I especially remember a call with American Pathfinders the week after George Floyd's murder. She was a quiet presence, a listener, but also the person who created a sense that we could reckon with our organization's history and find our way forward. No matter the circumstances Pathfinder faced, Ros listened carefully, then reflected, and then managed always to provide encouragement for us.

Onward, she said, onward.

Unlocking Global Health

A t Pathfinder, we work to unlock the talent and inventiveness of all the world's women. So, it was natural that we would also ask ourselves the question: Are we unlocking the talent and inventiveness of all the people within our own organization? Of all Pathfinders?

The answer was a painful one: We were not.

Our organization was simply not set up to do so. We were organized like the vast majority of international health and development organizations with a headquarters in the United States and field offices around the world. Our headquarters was established outside of Boston for its proximity to our founder and initial funders—a very long way from Africa, South Asia, and the Middle East.

Strategic and financial decisions were made at the headquarters. Pathfinders working at headquarters had more say; they also had more autonomy, job security, and career advancement. In other words, they

had more power, with the result that most Pathfinders couldn't unlock their full potential in our work.

Global health and development organizations were built on colonial models created and reinforced over decades and, in many cases, over centuries. Yet, at Pathfinder, we know from our work that structures that are well established and regarded as norms can disempower some of the most important and talented people in the world. We know that these structures need to be examined and often need to be overhauled.

This is work we began well over a decade ago when our country teams comprised people from the countries and communities where we worked. Unlike many peer organizations, we have not used an expatriate model to bring in staff from the United States. This difference was instantly visible in the pandemic when U.S.-based organizations brough expatriate staff back to the United States. We had only one American working globally allowing continuity of leadership, while some other organizations had hundreds of American expatriates to return to the United States.

Given our history relying on local staff, we knew that we could keep doing better, and in 2017, we began making a series of major changes to operate in new ways. We called this effort One Pathfinder and placed our country-led strategy at its center. This work fundamentally shifts accountability, decision-making, leadership, and key roles away from a U.S. headquarters to South Asia, Africa, and the Middle East where our country teams work with communities.

We came to understand that it was one thing to support this idea yet another thing to live up to its meaning in practice. This transformative work has been some of the most uplifting work I have ever been a part of and some of the most difficult. Making the shift from an American-dominated development organization to a country-led

model is not for the faint of heart. It requires a thick skin to withstand some of the reactions.

While our very mission has always emphasized change, we have, in certain ways, found it hard to change ourselves. Yet, we know that just as we invite communities around the world to be open to new approaches, even if they find it hard, we must ourselves have that same openness to new approaches, even if we find it hard.

As we began this work, several things quickly became clear. We needed to bring decision-making closer to the point of impact. That meant putting decisions around strategy, partnerships, and funding priorities in the hands of people coming from and residing in Africa, South Asia, and the Middle East. They could fully understand the context and setting where our work is done, because they shared the history, language, and culture of the places we work.

Of course, the concept of engaging local communities in developing their own solutions for their own challenges is not a new idea. Paolo Freire's book, *Pedagogy of the Oppressed*, published in 1968, powerfully spread the wisdom that profound change occurs when we enable those most directly affected to transform their own lives and circumstances.[65]

I had the rather staggering experience of having coffee with Freire when I was eighteen. He was based at the World Council of Churches in Geneva, and I was a part of a church youth delegation holding a meeting there. He gave me the Norwegian translation of *Pedagogy of the Oppressed*. When Freire handed me his book in the language of my ancestors, something shifted inside me. When I think about my deep commitment to our country-led strategy, I know that it comes, in part, from my Norwegian roots and from knowing that Norway,

65 Paulo Freire, *Pedagogy of the Oppressed*, 4th ed. (New York: Bloomsbury Publishing, 2018).

itself a colony until 1905, was a low- or middle-income country and had the people, wisdom, and capacity that it displays on the world stage today. I know that talent and wisdom exist everywhere waiting to be unlocked and that my responsibility lies in helping unlock it.

In the fifty-plus years since Freire's transformative book, the concept of engaging local leaders in development solutions has been widely applied. But—with few exceptions—it has not been extended into reshaping the leadership structure, strategy development, and financial flows of international organizations. Local consultations occur around program design and development, but the power to shape events remains at headquarters.

We recognized that we had to change who was in charge and where they were based. The most pivotal change was establishing a new kind of headquarters in Africa and South Asia. In this model, the field is not the periphery. It is the core.

When I am asked now where Pathfinder headquarters are, I reply with the locations of our presidents. Lydia Saloucou Zoungrana and Tabinda Sarosh guide Pathfinder from Ouagadougou, Burkina Faso, and Karachi, Pakistan, respectively. Together, we make decisions about strategy and resource allocation across the organization.

Some of the changes we made were in new language to describe ourselves: country leaders became "country directors" rather than "country representatives." We dropped the term "home office" or "headquarters." We try to move away from the rhetoric that implies U.S. dominance, such as a tendency to talk about "capacity limitations" as a way to discuss the need to strengthen functions in our country offices but not using that same rhetoric when we discuss the need to strengthen functions within our U.S. offices.

Language is hard to change, but it is vital insofar as it influences and shapes mindsets. Mindset embodies the deep, often unexamined

or unarticulated, assumptions that govern an organization. A change in mindset changes everything about how situations are understood and approached. And a shared mindset is a powerful way to align across an organization. Mindset governs action, and actions reinforce mindset.

One of the mindsets we needed to change is found in the adage that the goal of international organizations and the Americans working in them is to "work their way out of a job." This adage implies that, at some unnamed future time, the work of global organizations and American teams will no longer be needed, because local leaders will be ready to take over the responsibilities that American staff now hold.

This mindset is limiting and damaging, because it embeds unequal arrangements and sidesteps the need to build resilient organizations that combine the benefits of local leadership with access to best-in-class capabilities that can be located globally. Moreover, it validates the shift to the United States for vital resources that support projects and creates a self-fulfilling prophecy about where money and resources belong. For Americans working in global development, this mindset also limits their opportunity to learn new skills, innovate, and build their careers by trying out new roles instead of finding themselves locked in a cycle of repetitive tasks and job responsibilities.

My colleague, Biniam Gebre, came to our work with a fresh eye, spotted inequities, and helped us find solutions. Born in Eritrea during a period of war, he grew up in refugee camps there and in Sudan before reuniting with his mother in the U.S. where they lived in public housing. He went on to lead public housing for the United States in the Obama administration and do important work for global consulting firms. He joined the Pathfinder Board, telling me that his then fourteen-year-old daughter had counseled him to do so after reading our website. As we developed the country-led strategy, he

stepped down from the board to work with my colleagues and me to establish the office for the African presidency at Pathfinder.

Biniam, in his consulting roles, had seen the extraordinary economic growth that took place over the past twenty years in Africa, South Asia, and the Middle East and with it the proliferation of the professional class in many countries targeted for international aid. He saw the new ecosystem that emerged, which challenges the viability of a mindset based on the belief that professionals in North America and Europe are simply providing services that professionals in Africa, South Asia, and the Middle East cannot provide for themselves.

When we began this process in 2020 building on the OnePathfinder Initiative, only 6 percent of global roles were in countries; by 2023, 37 percent of global roles were in countries. Advances in technology have been powerfully important to this shift as shared systems bring teams together and instill common approaches across geographies. In addition, the necessity of virtual teams and remote work during the pandemic puts jets under this strategy, quickly and clearly demonstrating the power of deepened connections across global teams.

The vital importance of breaking the long-standing convention linking location and authority hit me like a thunder bolt on my trip to Niger in March 2017. Like many good insights, it came early in the morning over a cup of strong coffee. In this case, I was in Zinder, a regional center in eastern Niger, and I was sitting outside drinking coffee waiting for a day of events and meetings to begin. My Pathfinder colleague and our Niger information technology leader Aziz Alhousseini joined me, and when I said good morning and asked how he was on this beautiful day, Aziz replied with a weary smile, "I'm waiting for Boston to wake up." When I looked at him quizzically, he added, "If I were in the US, you would hire me. I have a degree from

the University of Maryland. I worked for Citigroup for five years until we were all laid off in the financial crisis. Then I decided I wanted to leave Baltimore and come home to Niger. In the US, you would hire me, and I would have authority. But now, since I am here, I have to wait for Boston to handle things. This morning, I am waiting for a simple password issue to be addressed ... when Boston wakes up."

I was stunned and galvanized. Following that visit, and in order to fix this, we implemented our Follow the Sun information technology strategy that spread authority and responsibility regionally. We shifted from a U.S. headquarters model to a round-the-globe model for information technology support that literally followed the sun from India to Mozambique to Niger to the United States, with lead staff in each location. This allowed us to cover twenty-three hours a day and operate in multiple languages rather than have eight hours a day coverage only in English.

On days when this work is hard, I still hear Aziz's words in my mind.

As part of changing mindsets and practices, we're working to build country organizations based on a portfolio of diverse products and services rather than only on the implementation of individual, time-limited projects. Historically, country funding was often based on a project-by-project model, limiting the career opportunities of country-based staff. These changes have had an important impact on equity because project end points resulted in job losses. Pathfinder staff in Africa, South Asia, and the Middle East can now have the same job security and opportunities for career advancement as their U.S. colleagues because they can hold a project-specific role or a longer-term country or global role. Now, in our organization, if you work in Africa, South Asia, or the Middle East, you can have just as much authority as if you worked in the United States.

In recounting these changes, I am not suggesting that Americans aren't, or shouldn't be, a vital part of global work. I'm keenly aware that those of us who are American have a lot to offer. We can exercise our talents and inventiveness within country-led organizations, and I believe we should do so. I also believe we can use our skills to do the hard work of addressing inequities in our home communities.

Reflecting on my own role as an American working within a global and country-led organization led me to recognize two things. First, I need to be clear about how I, as an American, bring value to a country-led Pathfinder. It's my role to institutionalize these changes in decision-making, leadership, and processes that bring our country-led structure to life, and I do this by working to align our organization with this objective. It's my role to help raise the funds necessary for all of Pathfinder's work. I also know that it is important that I work on similar causes in my own country and community.

In sharing our recent efforts to shift to a country-led organizational structure, I want to point out that this shift has historical roots in decades-old Pathfinder practices. Tabinda puts it brilliantly:

> The underlying principle and philosophy at Pathfinder has always been that nobody knows the country or the system or the people better than the country office. We exist in support and in service of the country offices. They're the ones who know their landscape best. Within that overall structure, we work to ensure that country leadership has the resources and the opportunities to develop their country programs and meet the demands of our donors.

I've mentioned that these changes have been hard to make, but it has been even harder to make the necessary core financial shifts. Money is power, and its use shows what an organization values.

Whatever an organization says of itself, its priorities are expressed by where the money is spent and by who decides where the money is spent.

Over the past ten years, government and philanthropic donors have directed billions to support countries across Africa. They channeled the vast majority of these funds to projects in recipient countries through traditional international organizations headquartered in North America and Europe. While no firm amount has been calculated, a significant portion of those funds for development in Africa went to global staff, principally located in the United States, for the category that donor organizations call "indirect funding." Indirect funding supports functions critical to any well-operating organization, including areas like finance, information technology, human resources, audit, procurement, technical support, safeguarding of persons, and program oversight. What this means is that, in most organizations, while the core project or programmatic work is done in Africa, the indirect funds for these critical functions are almost entirely expended off the continent in the United States. We now have fresh opportunity using technology and other tools to do better.

Richard Horton writes about global health in a *Lancet* editorial in 2023: "The discipline claims to be concerned about the health of people living in low-income and middle-income settings. But the resources—human, infrastructural, and financial—underpinning global health are mostly concentrated in those countries already replete with power and money."[66]

66 Used with permission of The Lancet Publishing Group, from "Offline: The Case for Global Health," Richard Horton, *The Lancet* 401, no. 10389, P1639, May 20, 2023. Permission conveyed through Copyright Clearance Center, Inc.

A long-standing joke puts it another way. Development funding builds capacity for sure—in the Washington, DC, and Boston suburbs. Like many jokes, it expresses a difficult truth.

Pathfinder Profile

PANDEMIC MOBILIZATION

It was April 2021, in the middle of the COVID-19 Delta wave in India, and yet the day began beautifully for Manish Mitra, Pathfinder's India leader. A brand-new baby, his nephew, entered the world.

By evening, classic, sharp symptoms of COVID were clear. Manish was very, very sick. By the next day, Manish's wife was also stricken with severe symptoms.

Manish and his wife were living in New Delhi, a long way from their families in the eastern Indian state of Chhattisgarh. They were cautious during the pandemic, but even caution did not protect against the virulent Delta variant. In those days, simply being outside, even masked, could result in a COVID infection.

As part of a full range of steps taken to deal with the pandemic, Pathfinder expanded insurance coverage and gave each country leader funding to weather the pandemic based on the needs in their office. Using these funds, the Indian team purchased oxygen concentrators, personal protective equipment kits, and portable oxygen cylinders—a life-saving resource, given the exponential increase in demand for oxygen during the Delta wave. Manish doesn't know of any other local or international civil society organizations that expanded insurance coverage or provided this kind of discretionary funding in India during that time.

COVID tests were in short supply, and by the time Manish and his wife received positive COVID tests, his health was deteriorating rapidly. That night his breathing became labored, and just two nights later, as his oxygen-level plummeted, Manish began to lose his eyesight.

Hospital beds were scarce. Manish's wife, in her illness, coordinated with Pathfinder colleagues and friends who stepped in and used the oxygen concentrator purchased by Pathfinder to care for him at home.

Not long thereafter, it became clear that Manish was getting sicker and simply couldn't be treated at home any longer.

The hunt for a hospital bed was on. Finally, his wife managed to find a bed in a very crowded hospital. The hospital wing that accepted him normally had sixteen patients. Manish would be the thirty-seventh patient.

Given his perilous condition, the challenge of getting to the hospital seemed overwhelming. Manish calls it a miracle that a friend not only found an ambulance to help him but also waited at his side for nearly twenty hours until he was finally settled in his hospital bed after waiting in the parking lot and corridors for care. During that wait, his condition plummeted.

Once Manish was hospitalized, new challenges emerged. Doctors simply did not know how to treat advanced COVID-19 patients; they didn't know what would work. They decided to try giving Manish plasma infusions from people who had developed COVID immunity from recent infection. As Manish's wife could not donate plasma, she reached out to one of his colleagues whose husband recently had COVID-19 and willingly stepped in. Then other Pathfinders and former colleagues also stepped forward to donate.

On the third day of his hospitalization, Manish felt just a bit better and thought to himself, I will live.

Yet, there was a long way to go. Doctors noticed patches on his lungs. Every second day, a patient near him died. Then, on day 13, Manish's doctors hurried to discharge him; a black fungus was spreading across and infecting COVID-19 patients. Late that night, he arrived home, exhausted, to his weak, but happy, wife—his unsung hero.

Over the next ninety days, Manish experienced major illness, temporary cases of glaucoma and diabetes as features of his illness, along with weight loss and muscle and bone pain that made it hard to sleep. His vision was significantly limited from double vision or diplopia.

Manish and his wife were recovering in isolation. People wanted to help, but that was a challenge, given the continued spread of the pandemic. Still, one person brought groceries, another medicine, and so on.

Manish was too ill to send messages. But each and every day during this period, Manish's then-supervisor, Rita Badiani, based in the District of Columbia, exchanged messages with his wife to check on his condition and share messages of support and care.

When Manish and I talked about it afterward, he shared that those daily messages of support and assurance lifted him. His voice trembled as he spoke to me about Rita, and it trembled more when he shared what it meant that we continued to pay his full salary throughout. "I will be grateful to Pathfinder for these policies until the day I die."

Ever so slowly, Manish returned to health. After contracting COVID in April, he texted Rita in June to say that he was returning to work. She replied with one sentence: "I am so relieved."

Five days after that text exchange, Manish returned to work, taking daily mid-day rest breaks for many months. He noticed that his colleagues had kept Pathfinder's work going and held open the space for him to step back into his role as the leader.

For decades now, funders and leaders of global organizations have been talking about "localization"—the transfer of power and resources from donor countries in North America and Europe to the countries and communities they are meant to benefit. The discussion has hit a new intensity in recent years, driven by the movement to reverse structural racism and address the ongoing inequities from the remnants of colonialism long calcified in Western institutions. Yet nearly all large development organizations are still headquartered in the United States or Europe and still privileging those locations as the places where core strategic and financial decisions are made.

Biniam says, "Donors have invested billions of dollars over decades in a vast body of knowledge and capacity in international non-governmental organizations based in the U.S. Those investments should not simply be set aside in moving to local organizations. Instead, all that work in areas like audit methodologies and compensation approaches and the robust infrastructure connected to it, in areas like finance, human resources, and compliance systems, can now be deployed in the countries where donors are aiming to have an impact, and provided by local talent."

I've mentioned that we are breaking this pattern by having country organizations have access to best-in-class global services. Crucially, these services are provided and staffed globally—in Africa, the Middle East, South Asia, the United States, and Europe.

Being a part of a global organization delivers key advantages for our country organizations:

Country-to-country learning. We learn from our successes and especially from our mistakes. For example, our Burkina Faso program has adapted adolescent and youth programs from Ethiopia and Mozambique, benefiting from candid conversations about what works and what doesn't. And our leaders across countries now have a community of peers with whom to discuss challenges and brainstorm solutions.

Best-in-class at scale. We invest in technology, processes, and systems. For example, we enjoy competitive pricing for services, and we hire renowned experts with deep technical knowledge in multiple disciplines to support the whole system at a level beyond the capacity of a strictly local entity.

Weather external shocks. The global system can help country teams get through military coups, terrorist attacks, civil wars, wildfires, disease outbreaks, pandemics, and typhoons—by sending in support fast. For example, during COVID-19, we provided money and flexibility as the pandemic swept across countries.

Oversight for safeguarding and stewardship. Our confidential system allows individuals to report wrongdoing globally, whereas they might not do so locally. Our SpeakUp culture and whistleblower process are vital. The majority of staff say they would not report misconduct without the protection of a global system. They simply would not report wrongdoing if they were required to report it to someone local.

In our country-led system, we knew we needed to put key decisions about global functions in the hands of our country leaders and ensure that country workers had easier access to those leaders.

Having access to leadership is yet another way of having the opportunity to lay claim to one's authority. When leaders are in the same country, in the same region, in the same location as the work, they are more accessible to the very people who wish to advocate for their programs or quickly raise and resolve issues that occur.

Here's just one example of how that transformation took place.

Our annual planning and budgeting process was historically a top-down exercise in which the global teams had first call on the budget for the vital funds that support projects and then allocated remaining funds to country teams for investment. The effect was that country leaders and teams understood their roles exclusively as implementers. We reshaped our budgeting and planning process so that it now begins with country leaders setting forth targets and plans, with the global functions following thereafter. This simple-seeming switch allowed the country leaders to participate in the process as creators and pursuers—clarifying and contextualizing commitments, setting clear targets, and giving voice to the need to do more or to do things differently. No longer were they mere implementers of others' already set ideas and plans.

This effort gave country leaders a greater sense of ownership and accountability. Tabinda pointed out to me that during the early months of our transition to being country-led, there was a certain reserve, even silence at times, among our country leaders. She saw these responses as evidence of a long-standing habit. Leaders were used to being invited to similar forums as token participants, expected to nod in agreement with whatever plans were being discussed.

Over time, those same leaders shifted first to offering their comments with caution and then, eventually, to adopting frankness and boldness as they questioned themselves, their global teams, and the organization overall. That shift toward freer and more consid-

ered participation also shifted leaders' sense of their roles from that of internalized adherence to that of deep accountability—the kind that comes from more increased ownership of idea-generating and decision-making processes.

As Tabinda put it:

> I think those of us from South Asia, Africa, and the Middle East need to be just as self-critical as our American colleagues. As the citizens of these regions, we have a larger responsibility toward our countries, and so it is imperative that we give voice to our knowledge, our concerns, and our critiques of the entire paradigm governing global development. The approach we are taking at Pathfinder is very revolutionary for every single one of us working within that paradigm and the systems to which it gives rise.

We are working to shift the traditional approach to knowledge building, by which knowledge gained in Africa, South Asia, and the Middle East has been used to build and support North American and European institutions. We are building a world where not only leadership but also knowledge gained from global health initiatives resides in the great cities of Africa, South Asia, and the Middle East where this work is done.

The progress we have been able to make in our country-led model offers one path for greater equity and stronger, more lasting benefits that advance the sexual and reproductive health and rights of people around the world.

I've said before that openness to change is exactly what we ask of everyone engaged in our initiatives—from funders to community and government partners to individual women and girls, men, and boys. Openness to change is also a standard we've set for our organization itself. In one sense, change comes naturally to us: Pathfinders are always navigating unfamiliar circumstances, finding ways around the cobras on the path. In another sense, change is more difficult. Renewing our organization to better sustain benefits to people around the world demands that we set aside outmoded models and norms. It requires deliberately and decisively setting out in the direction of ambitious goals and rigorously questioning and challenging the systems by which we operate to meet those goals.

It requires that when we set out to fulfill our primary purpose of empowering women and girls across the globe, we understand that power has many dimensions and that empowerment is a matter of *working with* rather than transferring or giving something over in such a way that it risks eliminating agency rather than strengthening it.

As we continue to make progress, we recommit to the ongoing work of self-criticism and review of the paradigms—both explicit and implicit—that shape our efforts. Doing so has, as Tabinda put it, revolutionary potential. Doing so is also necessary when we set as our aim nothing short of emancipating the talent, energy, and inventiveness of the world's women and girls. Ensuring that their power is in their own hands is, after all, our work.

As we press forward, pursuing necessary revolutions in our mindsets and our choices, we emphasize innovations that emerge among women who understand firsthand the problems that need solving. We are already pursuing a future in which women generate key catalytic ideas and then collaborate with seasoned entrepreneurs and leaders to test, pilot, and scale their concepts and plan for opera-

tional challenges. We are right now pursuing a future in which the facility and ease young people show in using new technologies can help them create revenue-generating opportunities. We are pursuing a future in which innovative models allow government-driven health programs to sustain infrastructure and fund health system upgrades in the midst of political changes and other power shifts that would otherwise destabilize these projects.

We never lose sight of our purpose, yet we learn and adapt as we encounter obstacles along the way. And we see new possibilities when we step forward.

That's because we know that paths are made by walking.

Conclusion

If you have come here to help me you are wasting your
time, but if you have come because your liberation
is bound up with mine, then let us work together.

—**An Australian aboriginal expression attributed to Lilla Watson**

Most of us, when asked what we want for the next generation, arrive easily at the idea that we want a better world. But in a world full of crises—coming one after another—how in the world do we get to something better?

We are, I think, well aware of what can go wrong. Less so about what could go right.

At the start of this book, I introduced some questions that inspire my work at Pathfinder: How do each of us make meaning in our lives? How can we turn our experiences and values into concrete benefits for ourselves and for others? And how do we ensure that we're doing something *big enough* in the world, especially when the many chal-

lenges around us can seem so overwhelming? Who really runs the world?

In these pages, we see that the great unlocking move of our time—the move we *can* make—is investing *enough* in the world's women.

Another way of putting that is this: whatever your purpose or your passion, whatever your specific cause, the world's women, too, are your cause.

Many women across the globe already have received a great education, safe and supportive reproductive healthcare, and the opportunity to earn and keep a living. I see how those of us who have been given the access, care, and economic opportunities to choose our own paths in life make a difference in our own lives—and in the lives of our families, our communities, and in the world. We show that this is the twenty-first-century unlocking move. We are the evidence that this is so.

But most women globally are still not receiving an education, still not receiving reproductive healthcare, and still without the chance to earn and keep a living. Giving all the world's women these tools is precisely what it will take to build a better world. It's about time we do just that.

We have many remarkable ideas, technologies, financial instruments, and scientific breakthroughs. But they are not enough. Without unlocking women's formidable intelligence and capacity, we won't get there. We will suffer the consequences of persistent extreme weather, insufficient health systems, and economic distress.

Doing *enough* requires a shift in our mindsets and our priorities. It requires courage, so we don't give in to the feeling that today's problems are simply too big for us to make a measurable difference.

And so, dear reader, now we come to you. Where will you decide to put your energy, your financial resources, your time? What structures will you challenge and change? The world is ours to run—it's time we lace up our shoes and join the race.

Acknowledgments

For centuries, remarkable people have understood the full humanity of women in the face of the societal norms and practices that have held women back. In the past decades, remarkable women and men have spoken up—and put their energy and money to work—to realize a vision where everyone has access to the modern reproductive healthcare available today. We stand on their shoulders.

A remarkable set of leaders today in Africa, South Asia, and the Middle East in governments, healthcare systems, civil society, and religious communities advocate for and deliver healthcare for women and their families each and every day. Thank you for entrusting Pathfinder as your partner in doing work so important to you and your community.

The leaders within governments, philanthropies, and multilateral organizations that support global access to reproductive healthcare and advocate for more investment change the world for the better. Thank you for fighting the good fight year in and year out.

A brilliant and growing group of American individuals and families give significant financial contributions to Pathfinder each

year. They understand that this work advances all the causes about which they care so deeply. Thank you for using your funds to create a better world.

A heartfelt thanks to the entire Pathfinder community. Pathfinders are so true to their name—finding new ways to do important work and finding new ways to sustain it. Pathfinders bring courage, innovation, and empathy to their work, especially in the most difficult moments.

The Pathfinder Board of Directors started and has sustained the journey to a more inclusive, country-led Pathfinder. They demonstrate their deep, abiding commitment to unlocking the energy, talent, and inventiveness of all people through the way they ask my colleagues and me the most important questions and offer their guidance, time, and experience so generously. Thank you for your world-changing leadership.

I have been fortunate to serve with three inspiring and inspired board chairs during my tenure: Richard Berkowitz, Roslyn Watson, and Collin Mothupi. They have given me such excellent counsel and widened my perspective. I also want to thank Tim Brown who has served as the board's vice chair throughout most of my tenure. His unfailing optimism lifts us all.

Past members of the Pathfinder Board of Directors and earlier Pathfinder leaders built a foundation for our organization and achieved leading results over decades. I want to especially thank Pathfinder's former CEO Dan Pellegrom and long-serving Pathfinder Kate Bourne.

Over one hundred leaders and experts serve on the Pathfinder Presidents' Council members, providing my colleagues and me with insights, counsel, and encouragement. Thank you for your counsel and support.

I thank Pathfinder's presidents Tabinda Sarosh and Lydia Saloucou Zoungrana. We stand by each other's sides, guide, and challenge one another. Like women leaders so often do, we step in with kindness and care, celebrating graduations and weddings and condoling the loss of loved ones. A special thanks to Tabinda for accompanying me over WhatsApp as I sat with my sister those nights at the Mayo Clinic during her last days, days that coincided with the start of writing this book.

My thanks, also, to Biniam Gebre, whom I initially met as a Pathfinder board member, for agreeing to step down from the board and take up a management role to bring to life the country-led strategy so essential to our work. Thank you, Biniam, for setting aside your own plans to accelerate our progress.

Mengistu Asnake and Crystal Lander played early, valuable roles in the formation of this book. My deep appreciation to Darlene Irby, Manish Mitra, Marie-Claude Mbuyi, Joseph Komrihangiro, Amina Dorayi, Jodi DiProfio, Mohamed Abou Nar, Mahi Bebawi, and Seyi Bolaji. I thank Pathfinder leaders Sani Aliou, Agiuma Tankoba, Irenee Ndabagiye, Ayesha Rasheed, Ernest Konan Yao, Ritah Waddicombe, Ginette Hourikam, Pamela Onduso, Mahbub Alam, and Joaquim Fernando for their partnership in the development of this book. An early morning conversation over coffee with Aziz Alhousseini in Zinder, Niger, sharpened my thinking about the country-led strategy in a particularly vivid way, and I thank him for his candor.

Christopher Dorval's clarity after a jarring visit to Mulago Hospital in Kampala gave energy and urgency to the inception and launch of Saving Mothers, Giving Life at the state department—and since then, in ways big and small, working with Pathfinder, he has given that same clarity to our cause so that women and girls can run the world.

My collaborator on this project, Jennifer Holt, made my ideas so much clearer, and her bountiful laugh made the writing of this book so much fun. Her gift is to bring out the best in people. Thank you for choosing me.

This book is about unlocking the talent and inventiveness of the world's women. As one of the world's women, I have had the help of scores of women and men in unlocking mine. It will take another book to thank them all.

I want to thank my family and friends for their love and support over these years and during the period of writing this book. A special thanks to my parents, siblings, and the extended Quam/Kvammen, Bergh, Larson, and Hammer families.

My husband, Arshad Mohammed, has a way with words that helps me better understand myself and the world. I am grateful for his love and kindness and especially for the joy he and his children Aziz and Sophia have brought to my life.

My gratitude to my sons Ben, Will, and Steve, who are at the heart of my story, and to the women they married—Jayne Reynolds, Nicola McConnell, and Laura Tucker—and to Noah, Cora, and the other precious grandchildren to come—is beyond words.

Further Reading

Unlocking the Talent and Inventiveness of Women

Bigio, Jamille, and Vogelstein, Rachel. *Understanding Gender in Policy*. New York: Council on Foreign Relations, 2020.

Gates, Melinda. *Moment of Lift: How Empowering Women Changes the World*. New York: Flatiron Books, 2019.

Dhawan, Erica, and Joni, Saj-nicole. *Getting Big Things Done: The Power of Connectional Intelligence*. New York: St. Martin's Press, 2015.

Johnson, Ayana Elizabeth, and Wilkinson, Katherine K., eds. *All We Can Save: Truth, Courage and Solutions for the Climate Crisis*. One World, 2020.

Mapp-Frett, Latanya, *The Everyday Feminist*. Hoboken, NJ: Wiley, 2023.

Nordell, Jessica. *The End of Bias: The Science and Practice of Overcoming Unconscious Bias*. Metropolitan Books, 2021.

Global Health Science and Practice special supplement, Saving Mothers, Giving Life, vol. 7 (supp) 1, March 2019.

The Guttmacher-Lancet Commission on Sexual and Reproductive Health and Rights, May 9, 2018. https://www.thelancet.com/commissions/sexual-and-reproductive-health-and-rights.

Unlocking the Full Potential of Global Health Organizations

Faloyin, Dipo. *Africa Is not a Country: Notes on a Bright Continent*. New York, NY: Harvill Secker, 2022.

Abimbola, Seye, and Pai, Madhukar. "Will Global Health Survive It's Decolonisation." *Lancet* 396 (2020): 1627.

Kumar, Anu. "Five Years from Now, Who Will Be Setting the Global Health Agenda?" *BMJ Global Health* 6 (2021): e008045.

Legacy

Mann, Charles. *Two Remarkable Scientists*, New York, NY: Vintage, 2019.

Cleghorn, Elinor. *Unwell Women*. New York, NY: Dutton, 2021.

Walk with Us

Whatever your cause, empowering the
world's women and girls is your cause.

The best way to address the global challenges of the twenty-first century is to unlock the talent and inventiveness of the world's women everywhere.

We can give a new answer to the question: Who Runs the World? It's about time we do this.

We welcome you to join us on this path.

Join the Pathfinder community:

WWW.PATHFINDER.ORG/JOIN-US

Support women and girls with a donation:

WWW.PATHFINDER.ORG/TIME-TO-GIVE

About Pathfinder

Pathfinder is a locally led, global network that opens the door to opportunities for women and all individuals to thrive. We see each day in our work that reproductive health is at the foundation of a just and equitable world.

Driven by our country-led leadership and local community partners, Pathfinder brings together services and programs that enable millions of people to choose their own paths forward.

Lois Quam

Named three times to FORTUNE's list of the most influential women leaders in business, Lois Quam, Pathfinder's CEO since 2017, is a senior leader in the corporate, government, and civil society sectors.

At Pathfinder, Lois and her colleagues provide global leadership demonstrating the vital role women play, when supported, in addressing the central challenges of our day. Deeply committed to putting power and decisions closer to those who experience their impact, Lois relinquished her role as Pathfinder's President to form a leadership group with two other women – President Lydia Saloucou Zoungrana in Ouagadougou, Burkina Faso and President Tabinda Sarosh in Karachi, Pakistan.

Prior to joining Pathfinder, Lois served at the U.S. State Department as leader of President Barack Obama's Global Health Initiative

with annual U.S. investment over $8 billion addressing the biggest health challenges facing millions of people across over eighty countries. In the corporate sector, she was the founding CEO of a division of UnitedHealth Group, providing services to older Americans and low-income families across the United States through the Medicare and Medicaid programs and in partnership with AARP. A Rhodes Scholar from Minnesota, Quam has degrees from Oxford University and Macalester College.